POSTCARD HISTORY SERIES

Snyder County

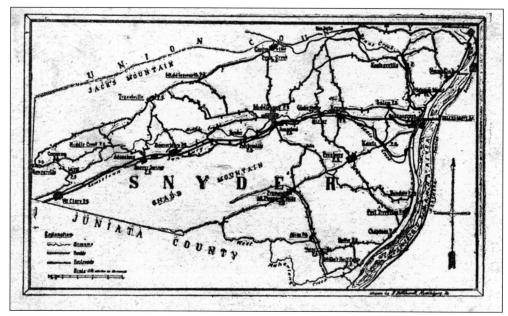

The 329 square miles that make up Snyder County are depicted before 1907; the date is established by the fact that the back of the card permits "address only." Both Middleburg and Swineford are shown (the communities joined in 1917), as are Selinsgrove and Selinsgrove Junction. Selinsgrove Junction is directly across the Susquehanna River from Selinsgrove in Northumberland County, and the two are connected by the Sunbury & Lewiston Railroad. Prof. Paul Billhardt of Middleburg faithfully rendered the county map.

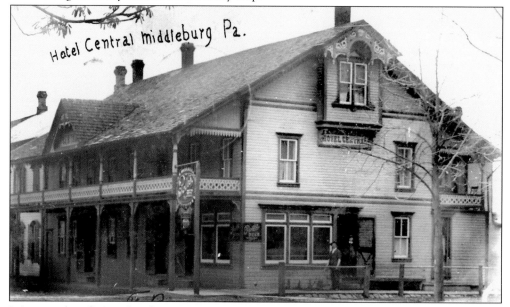

It is more than fitting that this 1907 postcard of the Hotel Central in Middleburg appears at the beginning of this book. It was provided by Ron Nornhold, who generously supplied the vast majority of the postcards in this publication. Ron's great-great-grandfather, Harry E. Emery, operated a store in this building for many years. An M&T Bank drive-up window occupies the spot now.

POSTCARD HISTORY SERIES

Snyder County

Jim Campbell

ARCADIA
PUBLISHING

Published by Arcadia Publishing
Charleston, South Carolina

Printed in the United States of America

Library of Congress Catalog Card Number: 2004114444

For all general information contact Arcadia Publishing at:
Telephone 843-853-2070
Fax 843-853-0044
E-mail sales@arcadiapublishing.com
For customer service and orders:
Toll-Free 1-888-313-2665

Visit us on the Internet at www.arcadiapublishing.com

For the people of Snyder County, past and present,
who are so much a part of this publication.

CONTENTS

ACKNOWLEDGMENTS

This postcard history is a companion book to *Snyder County*, in Arcadia Publishing's Images of America series. Like the previous book, this one would not have been possible without the help of many people, especially the members of the Snyder County Historical Society. Ron Nornhold, a lifetime member of the society, provided almost all of the postcards used in this publication. His collection of "Snyder County-ana" is second to none. As with the previous book, the tremendous research projects of two other men were the sources of many facts and figures: William M. Schnure's *A Chronology of Selinsgrove, Pennsylvania* and Dr. George F. Dunkelberger's *The Story of Snyder County*. Others who gave generously of their time and knowledge include Ray and Linda Adams, Carolyn Arndt, Teresa Berger, Bob Bickhart, Sue Boardman, Earl and Ruth Brown, Carolyn Burns, Brenda Campbell, Carl Catherman, the staff of Community Banks, Charles K. Fasold, Leon Earl and Carol Fetterolf, Joe Fopeano, Jim Forster, Chet Gaugler, Rudy Gelnett, Bob Gift, Sandy Gill, Gene Gordon, Bud and Ruth Herman, Ted Herman, June Hoke, Charlie Hoover, Ethel Ann Jones, Tanna Kasperowicz, Helen Keiser, LaRue Knepp, Lee Knepp, Marlin Kratzer, Mary Laudenslager, Jack Lindermuth, Lorraine Meadows, Harvey P. Murray Jr., Jim Pangburn, Joan Phelps, Rod Ries, Ruth Roush, Grant and Mary Lou Rowe, Jane Schnure, Jim Schnure, John Skotedis, Mabel Smith, John Snyder, Sue Sprenkle, Terry and Carolyn Sprenkle, Susquehanna Valley Postcard Club, Dave Troutman, Caralyn Van Horn, Rev. Beth Voigt, Cloyd Wagner, Richard and Nancy Wagner, Gene Walter, Joan Weber, Ken Wochley, and Bob Yerger. The author wishes to thank the staff at Arcadia Publishing, especially Brendan Cornwell, Tiffany Howe, Erin Loftus, Jim Skinner, and Laurie Butcher.

INTRODUCTION

The year 2005 is a special year in the annals of Snyder County. It marks the sesquicentennial celebration of the county's incorporation, which took place on March 3, 1855. The land that we know today as Snyder County—named in honor of Pennsylvania's only three-term governor, Simon Snyder, who served from 1808 to 1817—was created from parts of one of the commonwealth's earliest counties, Cumberland. However, it was not a direct line of descent. Part of Cumberland County became part of Lancaster County; part of Lancaster County became Northumberland County; part of Northumberland County became Union County; and eventually the southern part of Union County became Snyder County.

While it was not formally recognized until 150 years ago, Snyder County was settled long before that. Native American tribes, among them the Susquehannocks, roamed the region for centuries. Settlers, many of German extraction, began carving out a living here in the early decades of the 1700s. Dr. George F. Dunkelberger places the first settlement in the area at 1745. It was a hard life. The winters were unforgiving, and the thickly forested land had to be cleared, mainly by ax and ox, before it could be farmed. The Native Americans, though mainly nonhostile (if not friendly), sometimes went on the war path. The Penns Creek Massacre took place on October 16, 1755; its 250th anniversary is also marked this year.

Thanks to Conrad Weiser's skill in diplomacy, settlers and Native Americans coexisted in virtual harmony. A legend passed down from generation to generation relates how Weiser and Iroquois chief Shikellamy were sitting before a fire when the chief recalled a dream he had recently had in which Weiser gave him a fine Pennsylvania (or Kentucky) rifle. Weiser gave his firearm over to the Native American and said that he, too, had a dream. Weiser's dream had Shikellamy giving Weiser the land that is now the Isle of Que in Selinsgrove. The chief had little choice but to give the land to Weiser, but he said, "Let's neither one of us dream no more."

Snyder County grew and prospered, due in large measure to the strong work ethic of our ancestors. Farming was a major industry. Small factories sprang up; a significant number still exist. Lumbering and even mining operations—there were several iron furnaces used to process the ore taken off Shade Mountain—contributed to the county's total production value. Perhaps Snyder County's greatest asset through the years has been the industriousness of those who lived and worked within its 329 square miles. From the frontier days to the industrial revolution to the technological age, Snyder County residents have been willing, dedicated, and skilled workers. Whether building canal boats or bridges, turning out shoes or dresses, finishing cabinetry or furniture, the work force of men and women has provided quality products for consumption throughout the nation and the world.

The purpose of this publication is to show Snyder County life through vintage postcards, the vast majority of which were provided by Snyder County Historical Society lifetime member Ron Nornhold from his outstanding collection of "Snyder County-ana."

Postcards have been around for nearly as long as Snyder County has. Private cards, though not sanctioned by the U.S. government, first appeared in 1861. On May 1, 1873, the government began producing "postal cards" for messages only. It was not until the World's Columbian Exposition in Chicago (1892–1893) that the first commercial "picture postcards" appeared. The postage rate was 2¢ a card. In 1898, Congress approved legislation that dropped the rate to a penny a card. A boom in buying, sending, and collecting postcards followed. The cards of that era were required to carry the line "Private Mailing Card—Authorized by Act of Congress, May 19, 1898." On the back of the cards, no writing besides the address was permitted, which is why some pre-1907 cards have writing on the front. Some cards left a narrow strip on the front to facilitate a brief message.

The required phrase concerning messages was eliminated in 1901, and in 1907 messages could be written on the backs of the cards, which were divided, with one side for correspondence and the other side for the address. Many of the "view cards" were printed in Germany, in such cities as Berlin, Dresden, and Leipzig. Other cards were printed in Great Britain before the American printing industry developed the technology at home.

Two other events occurred by 1907, according to research by Marshall and Marsha Ledger. Rural free delivery (RFD) of mail increased to nearly 100 percent of the country, up from 25 percent, and the George Eastman Company (Kodak) gave an invaluable assistance to postcards' popularity by mass producing affordable cameras and manufacturing photographic paper cut to postcard size with preprinted postcard backs. These are called "real-photo" cards, and many examples are included in this book.

What the Ledgers refer to as a severe epidemic of "postcarditis" gripped the nation from 1901 to 1915, the height of the era of real-photo postcards. These cards are now highly valued because they were produced in such low numbers. It is likely that some could be one of a kind. For a while, the real-photo cards were overlooked and undervalued. But today, if the scene or people on a card are identifiable, it can fetch a substantial sum at auction.

The U.S. Post Office Department reported that 668 million postcards were mailed in 1907, and 968 million were sent in 1913. The latter figure is staggering. It represents 12 postcards sent for every man, woman, and child living in the United States at the time. Not counted were the millions of other cards that were never mailed but were put directly into scrapbooks or special albums specifically designed to hold postcards. The hobby of collecting and studying postcards is termed "deltiology."

It is hoped that this collection of postcards from the earliest days of the craze to the 1960s will give readers a better understanding of Snyder County, its people, and the rich history of our area. Enjoy!

One

ALL IN A DAY'S WORK

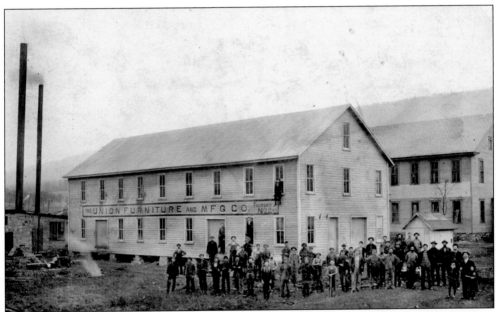

Workers, some quite young, appear before Factory No. 2 of the Union Furniture and Manufacturing Company's three plants in 1910. These McClure workers are typical of those who toiled in Snyder County's many workplaces, filling a diverse set of positions. Union took over a factory that had been used to produce Castolio soap, "nature's own cleanser," c. 1906. Factory No. 2 was built in 1907, and Factory No. 3 was built shortly thereafter. At its peak, the company produced 75 dressers a day. As many as 80 men (and perhaps boys) were employed by the company.

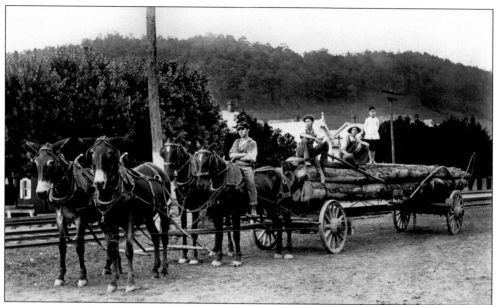

Lumbering was big business in the West End of Snyder County, especially on Shade Mountain and Jack's Mountain. This real-photo card of a four-mule and horse team was snapped in McClure *c.* 1911. Some white pines (though not these particular logs) could produce up to 2,000 board-feet of lumber. While many areas throughout the commonwealth were "timbered off," a stand of virgin forest, known as Snyder-Middleswarth State Park or Tall Timbers, still stands near Troxelville thanks to the conservation efforts of Ner Middleswarth.

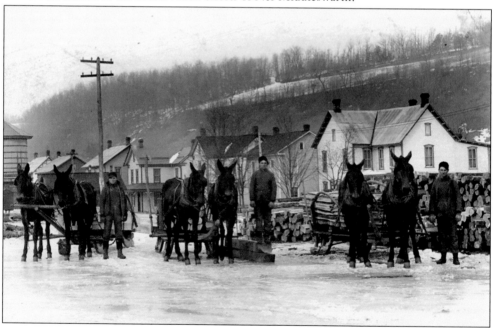

Not all lumber was transported by four-mule and horse teams; weather permitting, cut lumber was moved by two-mule sleds. This postcard depicts a McClure winter scene *c.* 1912. Unfortunately, the "mule skinners" are not identified. Snyder County timber was used for railroad ties, matchsticks, and everything in between.

A date stamp, not a postmark, on the back of this real-photo card reads August 11, 1911. The image is of the First National Bank of McClure. Pictured are, from left to right, Edward P. Benfer, young Josephine Wagner, Bruce Wagner, and an unidentified person. To the rear of the new building is the McClure post office. In 1954, the bank merged with other area banks—Beaver Springs, Middleburg, Richfield, and Selinsgrove—to form Tri-County National Bank, which has evolved into M&T Bank.

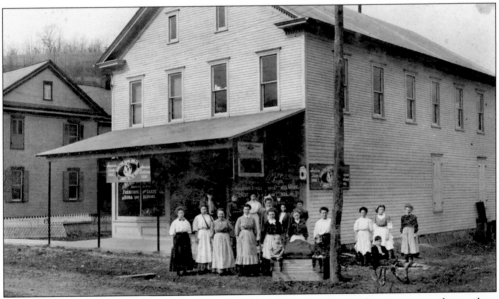

This is Henry Knepp's factory and furniture store in McClure c. 1907. The women are the workers employed by Knepp's second-floor Standard Shirt Company. Knepp's window advertises, "Dealer in all kinds of furniture and carpets, rugs and bedding." A sign also claims that the American Lady and American Man shoes made by the Brown Company are the "world's largest." Note the three youngsters, two on a box and one in a wheelbarrow. The building on Specht Street was destroyed by fire in 1961.

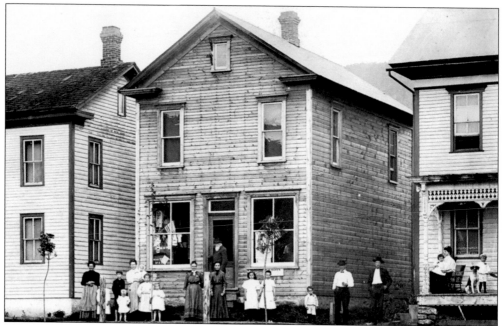

S. S. Baker was more commonly known as Doc, perhaps because he manufactured his own "medicines," which he sold for "illnesses and injuries." His McClure store, shown in 1906, was called a "racket shop" and sold "a little bit of everything." The building also served as a lodge hall for the Red Men, a popular fraternal organization at the time.

The circular sign on the pole reads, "McClure House, J. H. Stuck, Prop." This card from the summer of 1908 shows a man, presumably Stuck, standing in front of the establishment, which was also known as Stuck's Hotel. Like the many hotels of Snyder County, the McClure House provided meals and lodging for travelers and temporary residents.

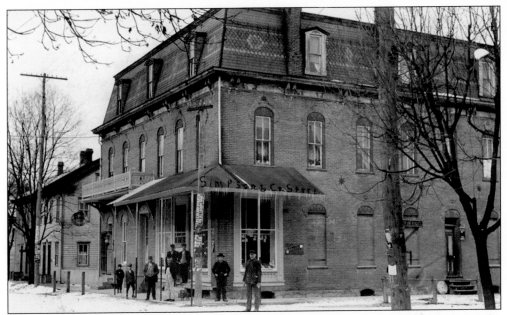

The oblong sign at the left front of this Beaver Springs three-story Victorian establishes the date of the building as 1888. The photograph is from 1910. By that time, a portion of the first floor housed the Simpson and Company store; earlier, the building was home to the Merchant's Hotel (also known as Stahlnecker's) and a store owned by H. M. Pontius. A vertical sign reads, "Celluloid Starch for all laundry work, use hot or cold."

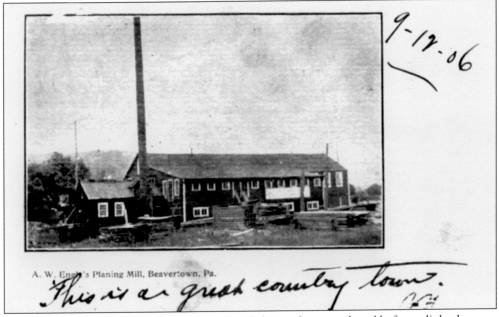

A. W. Engle's Planing Mill, Beavertown, Pa.

This is a great country town.

Postmarked "Beavertown September 12, 1906," this card was produced before split backs came into use. Thus, the message "This is a great country town" is written on the front of the card. Depicted is A. W. Engle's Planing Mill. Although located a town away, the Beavertown planing mill greatly resembles the Beaver Springs wagon factories.

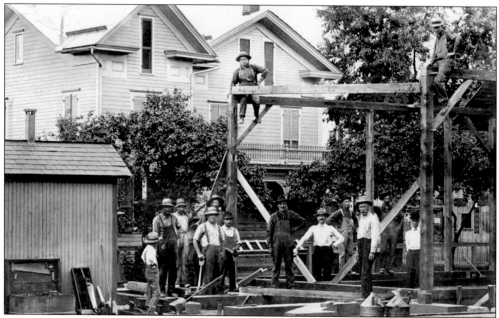

Workers take a break from rebuilding the Beavertown railroad depot to have their photograph taken on a summer day sometime in the first decade of the 20th century. Their saws and other hand tools can be seen leaning against the lower building at left. An inquisitive young boy looks on. The depot served the Sunbury and Lewistown Railroad, which was completed in 1871. As many as 50 trains passed through town each day.

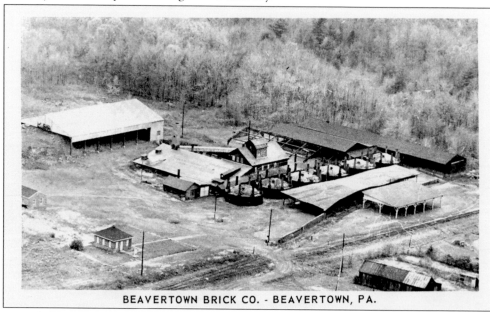

BEAVERTOWN BRICK CO. - BEAVERTOWN, PA.

A much later postcard, produced *c.* 1952, presents a bird's-eye view of the Beavertown Brick Company's brick-making operation. Brick manufacturing was a fairly common undertaking in the area between McClure and Middleburg. Note the storage shelters and the six neatly spaced kilns, which were used for firing the bricks. Glen-Gery, a big name in bricks, later took over the plant.

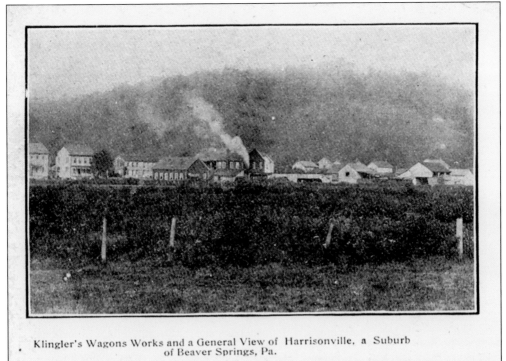

Klingler's Wagons Works and a General View of Harrisonville, a Suburb of Beaver Springs, Pa.

One may not think of Beaver Springs as ever having been large enough to have suburbs, but the facts are in black and white at the bottom of this pre-1907 card. Klingler's Wagon Works was located in Harrisonville, which may have been the section that became known as Frogtown. The facility opened in 1902. A portion of the foundation is still visible on the road to Penns Creek.

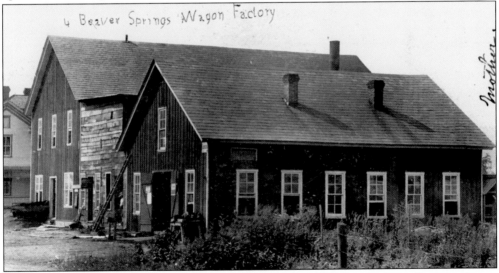

Since Beaver Springs had several wagon and buggy shops—the Kearns Motor Company began as a spin-off of one in 1907—it is unlikely that this is another view of Klingler's Wagon Works. The image is identified as "Beaver Springs Wagon Factory," but it is unclear if that is the actual name of the business or a generic description. The card was mailed from Beaver Springs to Philadelphia on December 7, 1907.

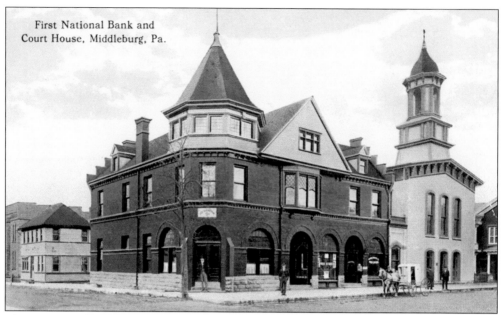

First National Bank and
Court House, Middleburg, Pa.

This A. E. Snook card pictures Middleburg's "town square," the intersection of Main and Market Streets. This *c.* 1914 view shows the First National Bank and the Snyder County Courthouse. The bank on this corner has undergone several name changes and is currently known as M&T Bank. The light covering of the courthouse has been removed, and the original brickwork now shows. The courthouse has been expanded several times over the years.

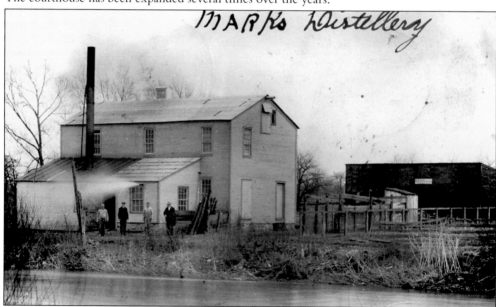

Pennsylvania has a long history with distilled spirits. Angered by an excise tax on whiskey in 1791, Pennsylvania farmers and distillers carried out attacks on excise tax agents. Known as the Whiskey Rebellion, the attacks were quelled by Gen. George Washington. Much later, in 1875, Joseph L. Marks of Middleburg produced "fine Rye whiskey" at a distillery at the base of Shade Mountain, near the current golf course. Prohibition crippled the whiskey industry, but legend says that stills continued to operate on Shade Mountain. This card is from 1907.

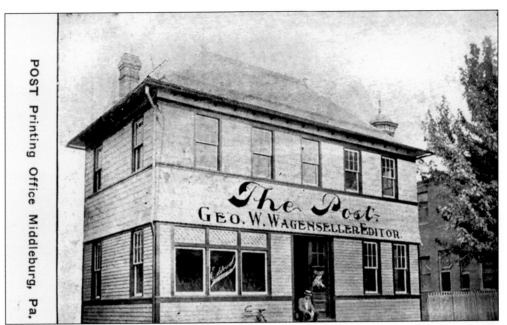

George Washington Wagenseller of Middleburg is a revered figure in Snyder County annals. He was instrumental in founding the Snyder County Historical Society. The author's previous pictorial history on Snyder County showed the interior of the Middleburg post office, with Wagenseller and his faithful assistant, Clara Winey, at work. This card offers an exterior view from *c.* 1913, a year after Winey joined the staff. She retired in 1972. Wagenseller is shown with his two-wheeler. He was editor-publisher from 1894 to 1928.

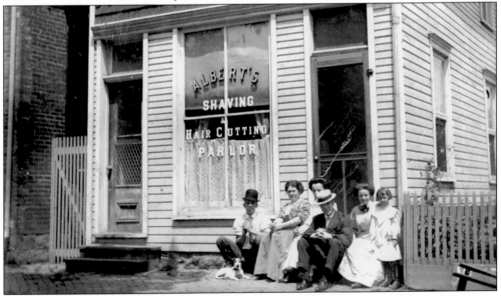

When this real-photo postcard was published during the first decade of the 20th century, Mr. Gillette's safety razor had not quite caught on. Men still went to the local barbershop for "a shave and a haircut, two bits." One such tonsorial establishment was Albert's Shaving and Hair Cutting Parlor in Middleburg. Note that shaving gets first priority. Of the group on the parlor's steps, only Nevin Willis, in the center, is identified.

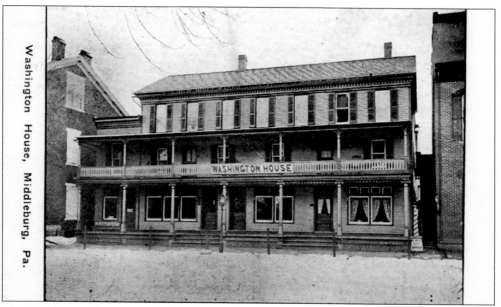

Washington House, Middleburg, Pa.

The Washington House occupied land on Market Square in Middleburg. In addition to providing meals and rooms for patrons, the hotel was the location of several "teachers' institutes" in the late 19th century. Later, the building housed Bing's Western Auto, operated by Mr. and Mrs. Nevin Bingaman. Today, a Subway sandwich shop is located in the space to the left of the hotel as viewed in this 1912 card. Note the barber pole to the right.

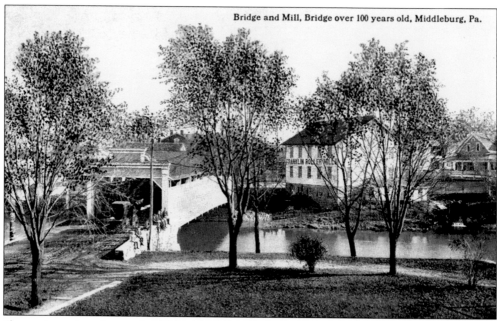

Bridge and Mill, Bridge over 100 years old, Middleburg, Pa.

Shown is another view card published by Middleburg druggist A. E. "Aurie" Snook. Drugstores were among the county's leading purveyors of postcards. Depicted in this view of the French Flats section is the 100-year-old bridge leading from Middleburg to Swineford and the Franklin Roller Mills, which rolled wheat, rye, oats, and other locally raised grains. The card dates from 1913.

18

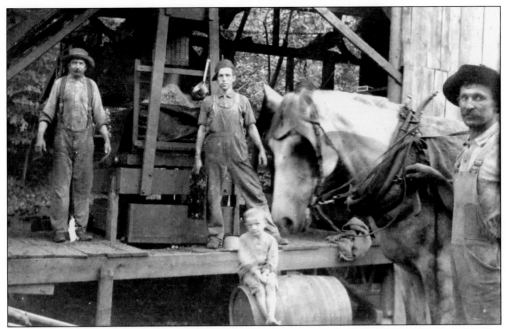

With all the apples being grown in Snyder County, it was only natural that there were cider presses to process the fruit into cider. The one shown in this real-photo card is located in the Middleburg area. A notation on the back states, "Guy H. Oldt at cider press," but it does not identify which person is Oldt. The card dates from *c.* 1912.

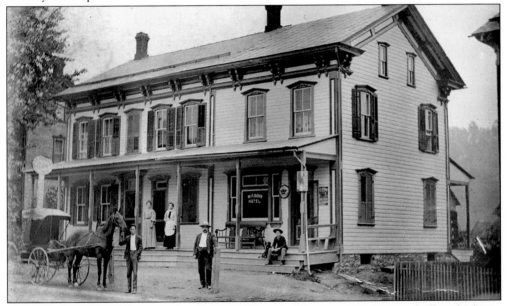

This Horton real-photo card from 1908 shows the W. A. Mohn Hotel in Troxelville, which was later bought by Henry Martin Berge. "Grandpa Berge" lived on one side of the building, and he helped to raise his granddaughters Mabel and Florence Bingaman, who occupied the other side of the building, after their mother, Berge's daughter, died at a young age. The building still exists. Close inspection reveals signs for Moxie—the soft drink of choice of a former generation—and Cold Spring beer.

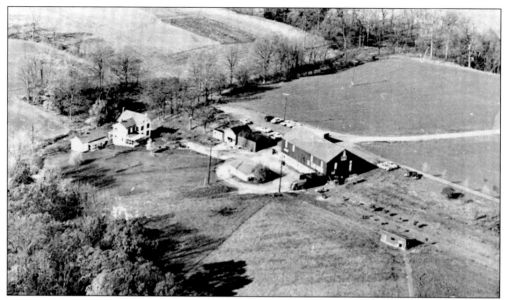

This postcard depicts Penns Creek's Walnut Acres in 1958. The 360-acre farm, founded in 1946 by Paul and Betty Keene, was America's first organic farm. People came from near and far to purchase "unchemicalized, natural food." Actor Robert Cummings flew in from Hollywood on occasion. The farm's first product was Apple Essence, an all-natural apple butter that received national acclaim in Clementine Paddleford's *New York Herald-Tribune* column. The operation was moved to Virginia in the 1990s. In the 1980s, the farm mailed out one million catalogs annually.

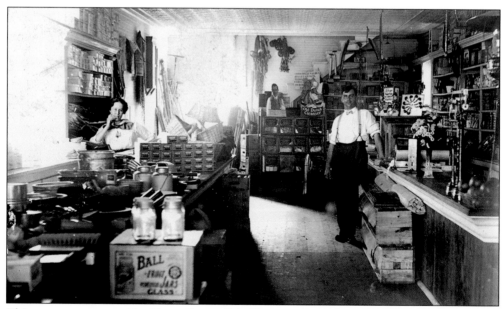

This store was operated by Harry Sampsell in Kreamer in 1919. It later became Long's Store. The people pictured have not been identified, but they are probably Mr. and Mrs. Sampsell. A close look reveals Ball brand canning jars, Old Dutch cleanser, and Kellogg's cereal. At the rear of the store is a double row of Nabisco cookie and cracker bins.

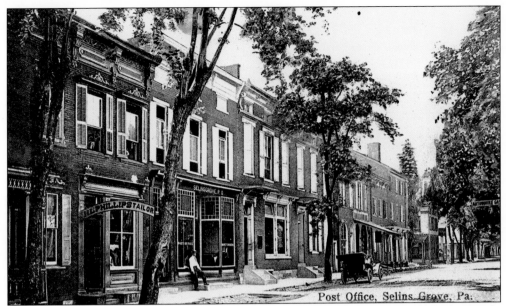

This card was postmarked September 21, 1912. The post offices of Snyder County, especially in the early years of the 20th century, were often located in convenient storefronts. In Selinsgrove, the post office was located in the first block of South Market Street, next to the First National Bank. Postal service began in Selinsgrove in 1808; Jacob Lechner was postmaster. The tailor shop of Henry L. Phillips, an institution for years, is the first business fully visible at the left.

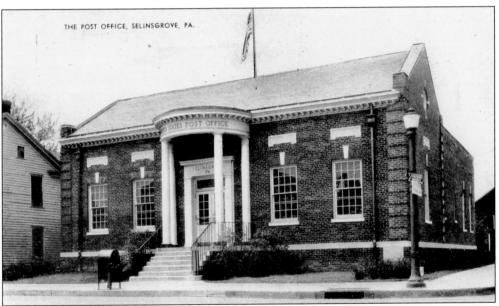

In the 1930s, the Great Depression gripped the land, and Snyder County did not escape its clutches. Later, government programs employed people in various public works projects under Franklin D. Roosevelt's New Deal. One such public project was the Selinsgrove post office, erected in 1935 at the corner of Market and Walnut Streets. Inside is an outstanding mural by artist George Ricky depicting Shriner's Church, the Susquehanna River, and Mahanoy Mountain. The mural can still be seen today.

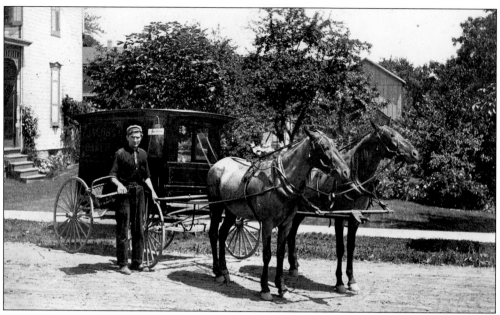

The author's previous pictorial history on Snyder County featured a *c.* 1910 photograph of Jacob, his horse, and his delivery wagon. Business for the Selinsgrove baker must have been good. By the time this real-photo card was produced in 1914, Jacob had doubled the horsepower of his delivery wagon. Jacob still promised, "Send in an order and it will be delivered free." The small sign to the right of Jacob's head reads, "Maple Nut Cake."

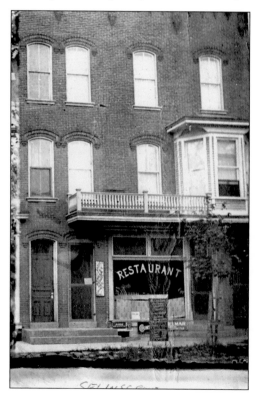

This real-photo card of Zellner's Restaurant in Selinsgrove was mailed to Mrs. Charles Beaver, a patient in Philadelphia's Lankenau Hospital, by Mrs. Romig on November 11, 1919, with best wishes for a "speedy recovery." Like many eateries today, Zellner's listed daily specials on a chalkboard outside. The vertical sign to the left of the entrance announces, "Ladies' Ice Cream Parlor and Dining." Lloyd Zellner operated the establishment. Eclectika is now located at the 24 North Market Street address.

The Penrith Shop at 29 South Market Street in Selinsgrove opened in 1944. A special couple, Russ and Madalene Grugan, operated the business at that location until 1958, shortly after this card was made. They were most kind to everyone, especially to a young "move-in" in the late 1940s. Russ, a skilled locksmith, also served as a Greyhound ticket agent. Madalene cheerfully oversaw many of the shop's other facets, including newspapers, magazines, and business machines. The Grugans moved the shop to 314 North Market and did business until 1970.

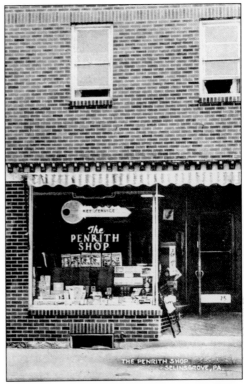

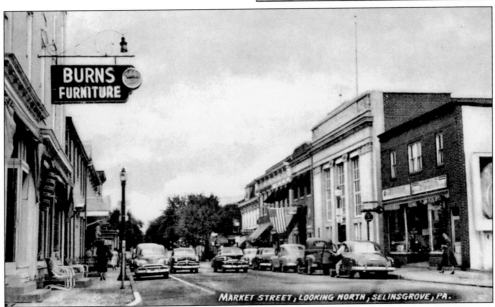

Taken from the corner of Market and Walnut Streets (now University Avenue), this photograph does not depict a drag race, just a car passing another car that is about to park. Burns Furniture was a family business for generations. It later became John Alden's and today is the Country Squire. On the right are two other Selinsgrove business institutions, Grugan's Penrith Shop (now the Basket Gourmet) and Wally Higgins's Family Shoe Store. The First National Bank, now M&T, is also on the right. The card is from the early 1950s.

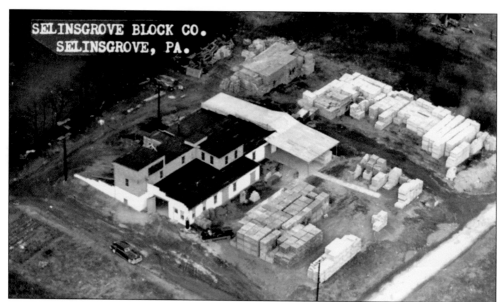

SELINSGROVE BLOCK CO.
SELINSGROVE, PA.

Opened for business in November 1935 and operated for a significant period of time by Robert "Bud" Whitmoyer, the Selinsgrove Block Company on North Eighth Street was a going concern. Cement blocks were produced by the hundreds of thousands (note the large stacks near the building). This 1950s card was sent out to prospective buyers, stating, "This fine plant is for sale at a very attractive price. Write: Kashfinder System, 101 North Water Street, Wichita, 2, Kansas." Fire destroyed the plant on Friday, November 11, 1963.

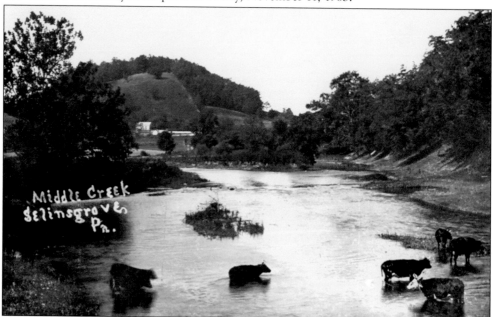

Middle Creek
Selinsgrove,
Pa.

Middle Creek, as its name indicates, is a midway dividing point between much of the northern and southern portions of Snyder County. It flows into the Susquehanna River at Selinsgrove. A small herd of cattle is shown near the mouth of the creek c. 1917. Anyone even remotely connected with raising cattle knows the amount of work involved. It is not a five-day week or a 40-hour week; the work goes on nearly all day, every day.

This real-photo card, postmarked from Freeburg on September 13, 1913, and sent to Mrs. Charles Dobson of Paxtonville, depicts the Empire House on Market Street in Freeburg. The staff and management provided patrons with outstanding meals and lodging. Now called the Empire Hotel, the business is best known for its fine food. Sam and Darlene Loretto are its proprietors. For many years, Pat Umholtz Livingston and her husband, Harold, operated the business.

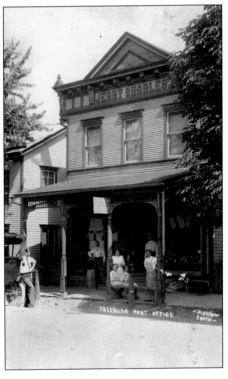

Jeremiah Charles constructed this building as a general store on Freeburg's Market Street in 1885. It is shown here in 1916. From the first decade of the 20th century, it also served as Freeburg's post office. Charles served as postmaster for 16 years prior to his death in 1924. Succeeding store owners were Harvey and Nora Troutman, Walter and Nora Straub, John and Mary Hoffman, George and Catherine Good, John and Ruth Reitz, Ray and Sara Alexander, and, for 43 years, Bob and Florence Shaffer.

This well-dressed group is most likely the work force of the Fremont Hotel. The real-photo card dates from *c.* 1908. During the golden age of postcards, roughly 1895–1915, photographers roamed the countryside—Snyder County included—taking photographs of nearly everything that did not move. The value of the cards, besides their use as historical references, is in their scarcity.

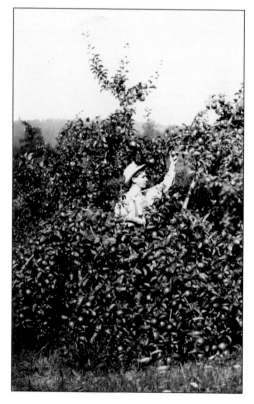

Fruit growing was, and still is, part of Snyder County's gross production. Apples are the largest crop, but other fruits are also cultivated. Although not as plentiful as before, many orchards still dot the county's landscape. In this *c.* 1917 real-photo card, a well-dressed worker, necktie and all, picks a ripe apple from a heavily laden tree on the Boyer fruit farm in the Mount Pleasant Mills area.

Two

Seventy-Six Trombones and Other Instruments

In the days before mass media and mass entertainment, people provided entertainment for themselves. Music was the most common form. Bands and individual performers were prevalent throughout Snyder County. No music institution in the county had more influence than Moyer's Musical College in Freeburg, shown here *c.* 1907. It was founded by Frederick C. Moyer in 1871. His sons, William and Henry B., succeeded him, as did his granddaughter Anna. The school closed in 1908, and the building was destroyed by fire on March 29, 1929.

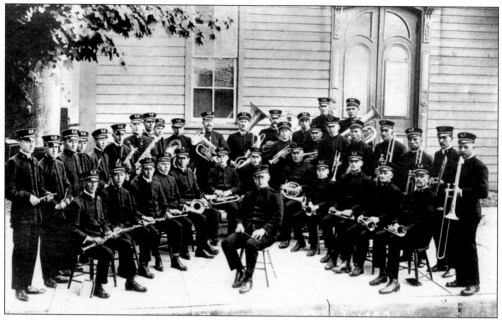

Nearly every Snyder County town had a community band. Shown are the 36 members and the conductor of the Beavertown Band in 1920. While it was 72 short of "76 trombones," the band had a fine array of instrumentation and undoubtedly provided music that pleased the ear. The musicians have not been identified.

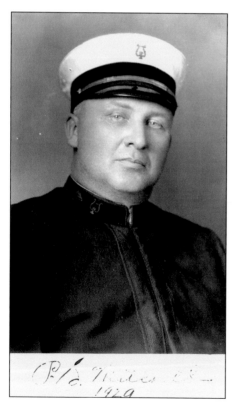

It is impossible to overestimate the influence of Palmer S. Mitchell (shown in 1929) on music in the West End of Snyder County. He organized the Beaver Springs Girls Band on July 8, 1918. Before passing away on October 30, 1948, "Music Man Mitchell" had the satisfaction of seeing his band perform at events ranging from World War I Liberty Bond drives to the 1933 inauguration of Gov. George Earle. Mitchell was elected president of the Pennsylvania Bandmasters Association in 1942.

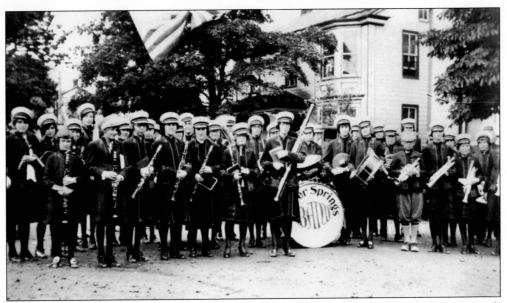

The Beaver Springs Girls Band, shown in 1926, was arguably the best known, best received, and most enduring of Snyder County's musical aggregations. In a 10-year span, culminating at Canada's Toronto Exposition in 1939, the band traveled 27,000 miles and earned $25,000. Most of the musicians were from the West End, but June Hoke of Selinsgrove played saxophone and was drum major for the band in several parades. A uniform and drum from the band are on display at the Snyder County Historical Society in Middleburg.

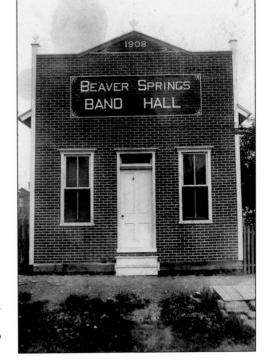

This card is timely. The date on the building is 1908, and the postmark reads, "Beaver Springs, October 17, 1908, 11 a.m." The building served as a rehearsal hall and instrument storage room for a Beaver Springs band—perhaps the Men's Band, whose disbandment during World War I gave rise to the Beaver Springs Girls Band in 1918.

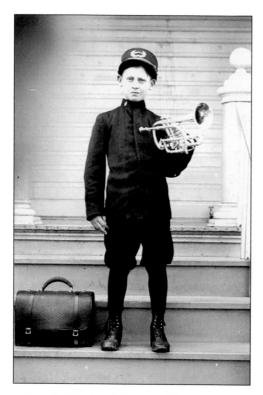

Hepcats who jitterbugged to the big bands of the 1930s and 1940s may remember bandleader Ray Anthony being billed as "the Young Man with a Horn." This is not an early photograph of Anthony, but the unidentified boy is certainly a young man with a horn. It is too compact to be a trumpet; perhaps it is a cornet or a flugelhorn. Judging from the lettering on his cap, the youngster could be a member of the *c.* 1912 Sons of Veterans Band.

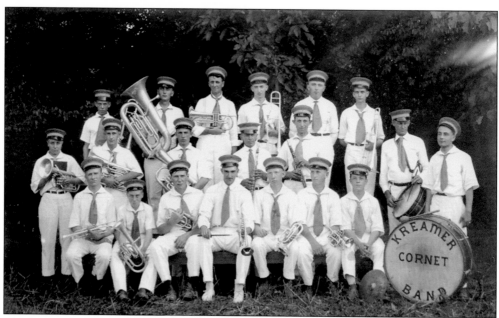

The late-1920s Kreamer Cornet Band was made up of 20 men. Although it was called a cornet band, other instruments are plainly visible. Photographic evidence shows that the band had been around since at least 1908. A successor to this band, the Kreamer Citizen's Band, was pictured in the author's previous volume on Snyder County history. That 1933 band, which was somewhat larger (it had 27 members), included both male and female musicians.

Three

THE PEOPLE'S PLAYGROUND

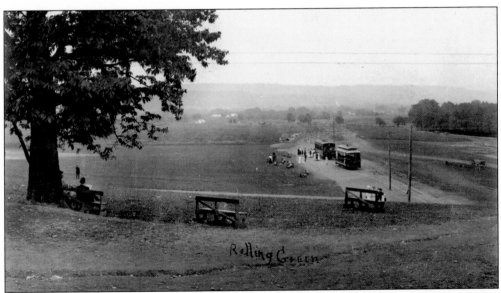

Rolling Green Park, or the People's Playground, was opened on Saturday, July 25, 1908. The land was purchased from Philip Teats for $49,841.66. This photograph was taken shortly after the Hummels Wharf park opened. Note the absence of the trolley station, which was built later and eventually became the penny arcade. The Sunbury-Selinsgrove Electric Street Railway was really the reason for Rolling Green's existence. The park, located at the midpoint of the Sunbury-Selinsgrove run, was created to entice riders.

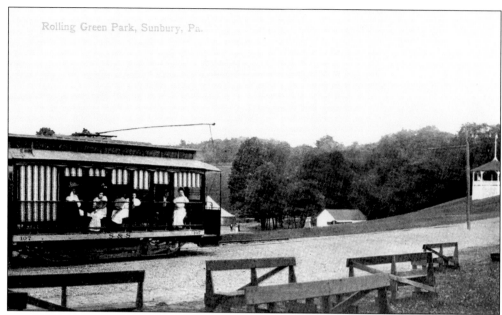

For those traveling between Sunbury and Selinsgrove on the S&S trolley line, the diversion to Rolling Green Park was a pleasant one. This card, published by C. F. Melnick of Sunbury, shows well-dressed women enjoying the open-car ride *c.* 1915. The car was one of those purchased in 1914 from Baltimore's United Railway and Electric Company. This card, like many others, was printed in Great Britain and is in color.

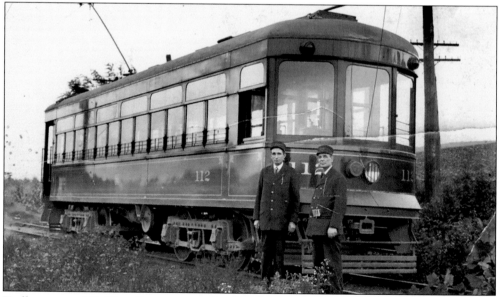

Trolley cars and Rolling Green go together like ham and eggs. The park came about because of the S&S line. There were three trolleys in operation when this card was produced around 1922: No. 111, No. 112 (shown here), and No. 113. The cars came from the Cincinnati Car Company. Conductor E. E. Gossler (left) and motorman A. B. Clemmons are pictured. The trolley company went into receivership in 1915. It later emerged, but it was eventually was replaced by BKW Coach Lines (buses) in 1935.

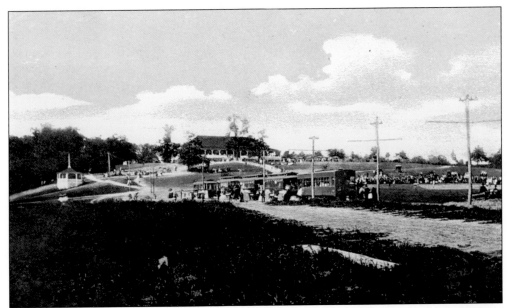

This *c.* 1914 card depicts a busy day, probably a summer Sunday, at Rolling Green. Like many Rolling Green cards, this one states the location as "Sunbury, Pa." Most locals know that Hummels Wharf was the home of the park. The gazebo (left) and dance pavilion (center) provide the background. From May 30 through Labor Day, beginning at 10:30 a.m. and running until 11:30 p.m., S&S trolleys entered Rolling Green on their runs from Sunbury to Selinsgrove. Cars ran about every 15 minutes.

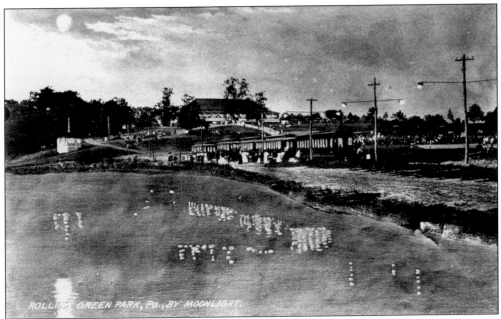

A close look will reveal that this card and the one above are identical in subject matter. A creative artist changed the time of day; the sky was darkened, a moon was added, and lights were affixed to the poles, inside the dance pavilion, in the cars, and reflected in "the lake," which in reality is a grassy field.

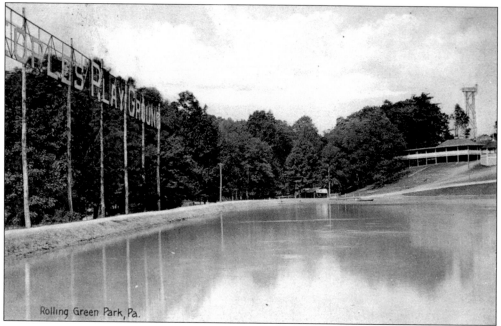

Rolling Green Park, Pa.

From its inception, Rolling Green Park was also known as the People's Playground. This view, published by "L.A. Benson, Selins Grove, Pa." and printed in Germany *c.* 1910, shows the lake, restaurant, and an observation tower. Interestingly, the location is identified as "Rolling Green Park, Pa." The lake is man-made.

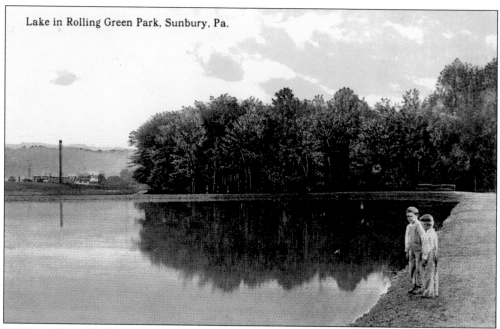

Lake in Rolling Green Park, Sunbury, Pa.

This is a view of the lake at Rolling Green Park from another angle. The two young boys could be contemplating the wisdom of testing the water. Once again, the location is erroneously given as Sunbury. At the left of this *c.* 1912 card is the trolley barn that became the Trailco (trailer) plant. It is now the location of the Dairy Queen on Routes 11 and 15.

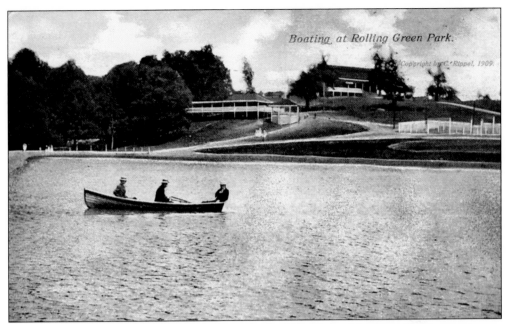

This card was never mailed, although the entire back is filled with a pencil-written message, indicating that it was probably hand-delivered. The card was published "for Conrad Ripple, Sunbury, Pa." It bears his 1909 copyright. Reminiscent of a nursery rhyme, could the "three men in a tub" be a butcher, a baker, and a candlestick maker?

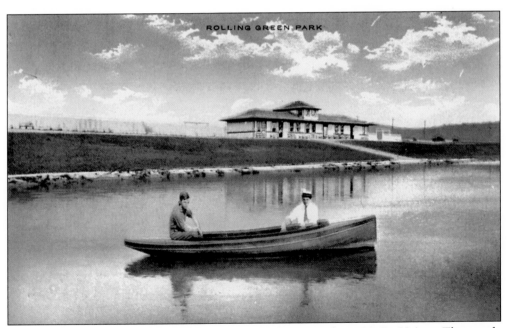

This is a *c.* 1923 postcard produced by another Sunbury merchant, N. R. Haines. The couple pictured is enjoying a popular Rolling Green pastime. In the years before most of the rides were added, the lake was a huge attraction. Note that a state-of-the-art trolley station has been built. It later became a penny arcade and a bus stop for BKW Coach Lines.

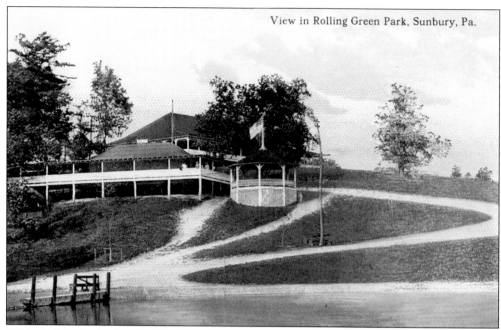

With the lake in the foreground and a colorful sunset (take our word for it) for a backdrop, this *c.* 1915 card is sure to stir feelings of nostalgia. The building in front is a restaurant that was managed for years by the Boyd Keiser family. Huge chicken and waffle dinners, at a price of 50¢, were a house specialty.

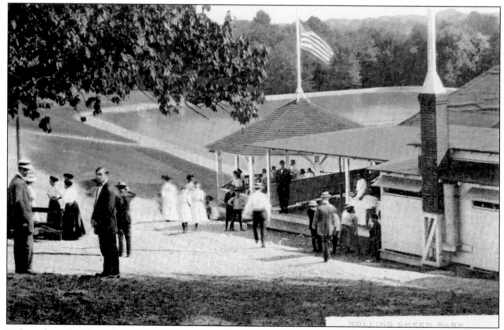

Taken from behind the restaurant seen in the previous view, this N. R. Haines card shows what is most likely a well-dressed Sunday group enjoying the clean air of Rolling Green Park. The card dates to the second decade of the 20th century. While the photograph does not show it clearly, the American flag is probably a 46-star version.

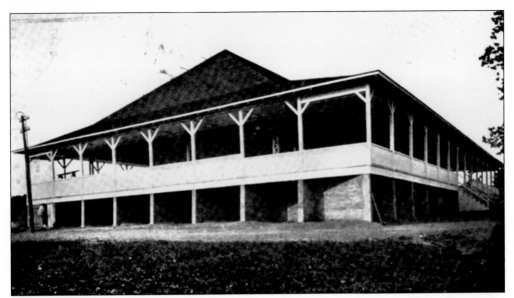

This card was printed in 1909 by "Heyman and Co., Shamokin, Pa." It shows the Rolling Green dance pavilion, sometimes called the Rainbow Ball Room. At the time, it was the ultimate in such facilities in central Pennsylvania. Local historian John W. Bittinger supplied information about its opening: "Joe Nesbitt and His Ten Pennsylvanians provided the music for the inaugural dance on Saturday, July 25, 1908." Many of the nation's top bands performed here, including the Fabulous Dorseys, Tommy and Jimmy.

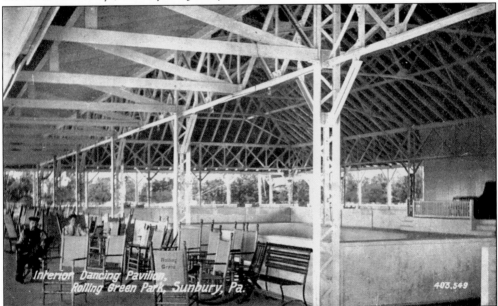

This 1908 interior view of the Rolling Green dance pavilion shows the dance floor and the spectator area. Since no orchestra is on the bandstand at right and there are no other dancers, the couple at the left is probably "sitting it out" and cannot be considered "wallflowers." Much later, record hops drew hundreds of teenagers to what became known simply as "Green dances." The Rainbow Ball Room continued to operate until it was destroyed by fire shortly before the park's closing in 1972.

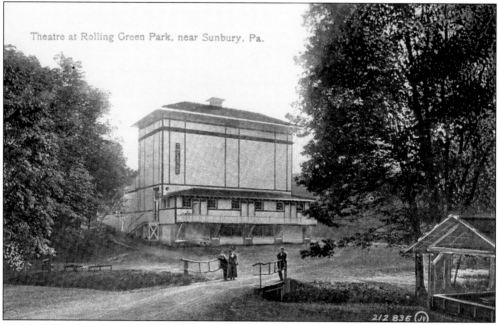

Theatre at Rolling Green Park, near Sunbury, Pa.

This building is sometimes identified as a theater, other times an opera house, but one thing is certain; it was the center of entertainment at Rolling Green. This rather pastoral view is from 1910. Once stage and vaudeville productions waned in popularity, the building was converted into a fun house and soda fountain (the lower structure in front of the building).

At first glance, these Snyder County lasses could be posing just about anywhere. However, a closer look at the building in the background reveals that it is Rolling Green Park's theater in the early days of the park, 1908–1912. Note the similarity of the architectural design seen in the previous card. The young men in the background may be these young ladies' beaux.

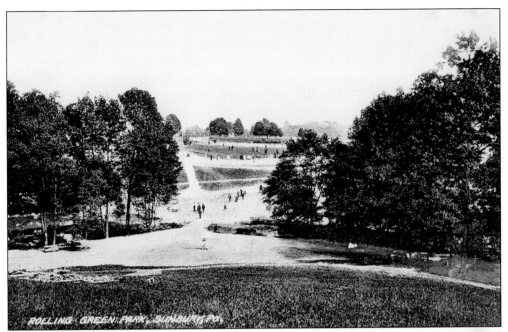

One of the early attractions of Rolling Green Park's 47 acres was a neatly laid out baseball field, seen in the distance on this 1911 card. At this time, even the tiniest of Snyder County's communities had at least one town team. Baseball was deeply woven into the fabric of America. This card was produced by Conrad Ripple, one of several Sunbury postcard publishers.

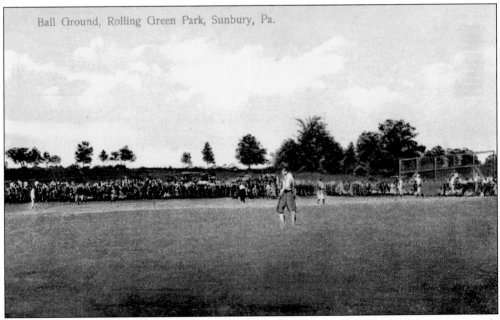

Printed in Germany in 1909, this closeup view of the "Ball Ground" at Rolling Green was made for another Sunbury card dealer, James VanDyke. A sizeable crowd is on hand for the contest, which probably took place on a Sunday afternoon. At this time, Saturday was still a full 10-hour workday for many workers.

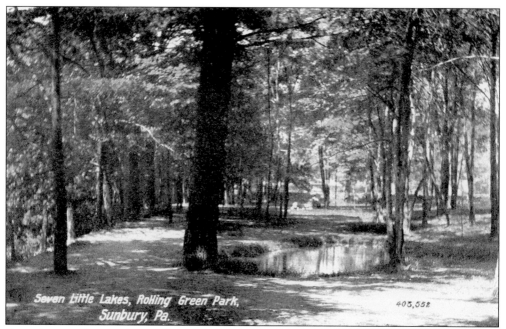

Seven Little Lakes, Rolling Green Park, Sunbury, Pa.

Even those well steeped in Rolling Green lore cannot offer much information concerning the Seven Little Lakes. As best as can be determined, the small ponds were in the area to the west of the main park attractions, among the picnic groves and pavilions. This 1910 card was printed in Great Britain and published by C. F. Melnick of Sunbury.

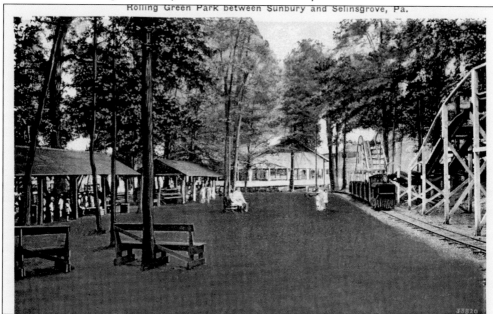

Rolling Green Park between Sunbury and Selinsgrove, Pa.

By the mid-1920s, when this card was printed, Rolling Green Park had added rides: the miniature train, the roller coaster, and the Dodge'ems (bumper cars). Picnic pavilions, always a big draw for family reunions and other gatherings, were still a reason for Snyder County residents and others to take an outing to the Hummels Wharf amusement park. Masonry fireplaces, with firewood provided by Rolling Green, were an added convenience.

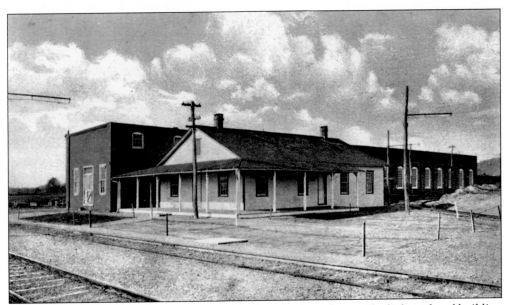

Although it is long gone and is remembered by few, the powerhouse (the light-colored building in this image) kept Rolling Green rolling and the S&S trolley line on track, so to speak. The building, shown *c.* 1913, was later replaced. The trolley barn and shop (the brick building) housed the idle trolleys and provided a place for repairs. Later, the brick barn and shop became Trailco, a facility used to build truck trailers. It was owned at one time by Ted Lash. A Dairy Queen now stands at the location.

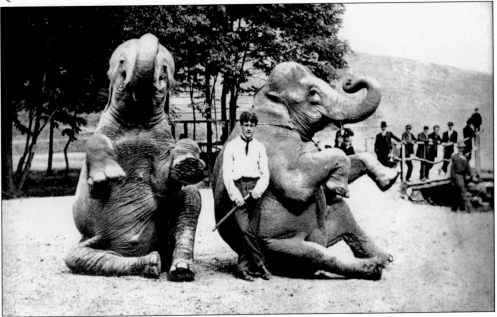

This is another card from Rolling Green Park. The card is from the early days of the Hummels Wharf amusement park, 1908–1919. In the days before major rides were added, animal acts were a big attraction. Here, a handsome young trainer and two of his weighty pachyderm performers provide amusement for an interested crowd. For big events such as the farmers' picnics and boatmen's reunions, crowds of 10,000 to 25,000 filled the park.

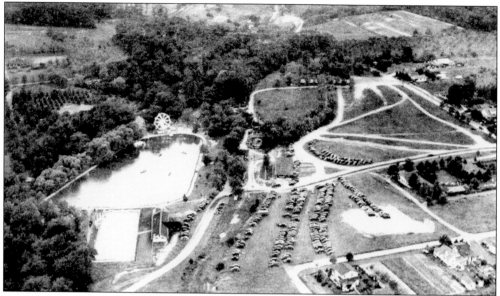

By the time this aerial view card of Rolling Green Park was made *c.* 1934, the production of postcards had become a domestic industry. No longer were most cards printed in Germany or Great Britain. This card was produced by the Albertype Company of Brooklyn, which modestly claimed its product to be "the finest American made view postcard." The name of Rolling Green Park was selected as the winner of a naming contest. Mrs. Charles Kissinger of Lewistown won the $25 cash prize.

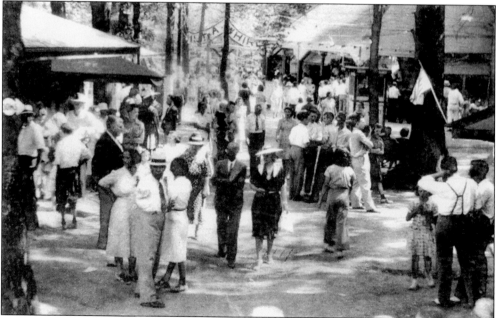

What is almost surely a pre–World War II Sunday crowd populates the midway of Rolling Green Park. While much comment could be made about how well dressed the crowd is—the men in ties, suits, and hats, the women in dresses and hats—one must remember that casual clothing was practically nonexistent at this time. Cruise wear and resort wear were exceptions, but they were usually worn only by the affluent.

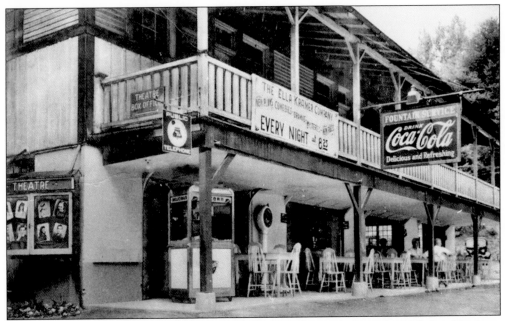

Before the theater at Rolling Green became the fun house, a soda fountain with the ubiquitous and seemingly mandatory Coca-Cola sign was part of the building. For the convenience of those who had just finished a burger or a shake, a scale was provided. A sign advertises the Ella Kramer Company, a theatrical group. Such vaudevillians as George Burns and Gracie Allen, Edgar Bergen and Charlie McCarthy, Nelson Eddy and Jeanette McDonald, Georgie Jessel, and Al Jolson appeared at the theater.

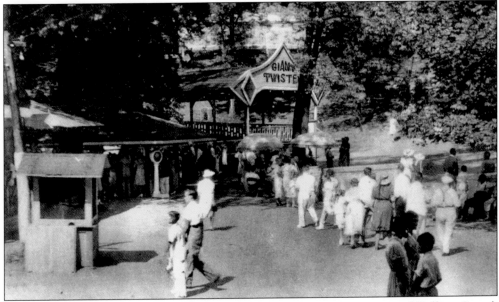

Another Albertype postcard from the late 1930s shows the entrance to one of Rolling Green's most favored attractions: the Giant Twister, a wooden roller coaster. It was built in Easton by Oscar Bitler in 1928. At the time of its completion, the Twister boasted the steepest drop and tightest figure-eight turn of any coaster in the United States.

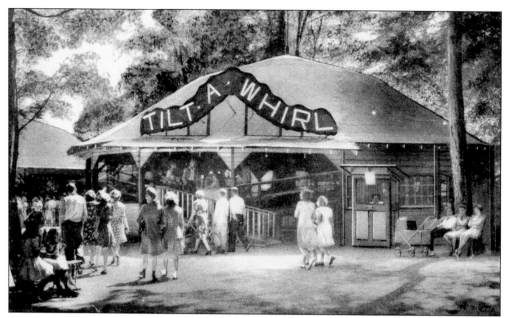

For those not up to the thrills and chills of the Giant Twister, there was the somewhat tamer Tilt-A-Whirl, which debuted in 1941. The ride consisted of a large circular platform that moved up and down as it revolved. Patrons sat in coaches that revolved within the revolving platform. Riding after a seven-course dinner was only recommended for those who possessed the proverbial cast-iron stomach.

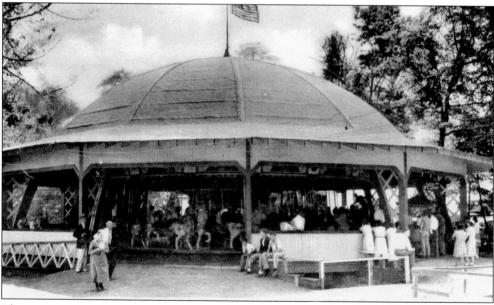

The merry-go-round at Rolling Green offered even more sedate amusement than the Tilt-A-Whirl. Its horses were carved in Philadelphia by Fred Christasen, a Danish sailor and woodworker. The original merry-go-round (built c. 1914) was replaced in 1944 by the one shown here. In 1972, the mayor of Ocean City, New Jersey, bought it for $18,000 and moved it to his Wonderland amusement pier at Boardwalk and Sixth Street. Snyder County residents and others can still try for the brass ring there.

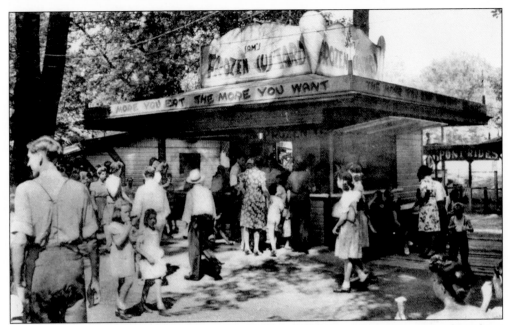

After a day on the Giant Twister, Ferris wheel, Tilt-A-Whirl, and merry-go-round, nothing tastes quite as sweet as a frozen custard—or soft serve, as it is known today. Fortunately, Sam's Frozen Custard stand, which first appeared in 1935 (shortly before this card was produced), was smack dab in the middle of the Rolling Green midway. Just walk up and order any flavor you want—as long as it is chocolate or vanilla.

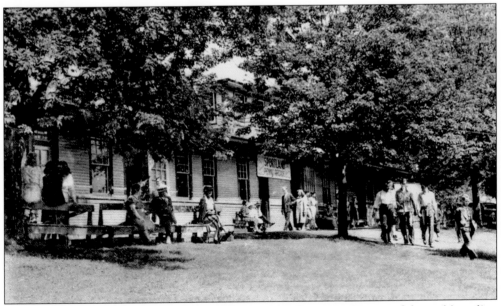

As the family automobile replaced the trolley by 1935, the need for one of the park's earliest buildings changed. While the trolley station was still used as a stop for the BKW Coach Line buses, the interior of the building became a penny arcade, or Sportland, as the sign indicates. The author succeeded his lifelong friend Bob Yerger as "change boy" at the arcade, his first part-time job, in the summer of 1951.

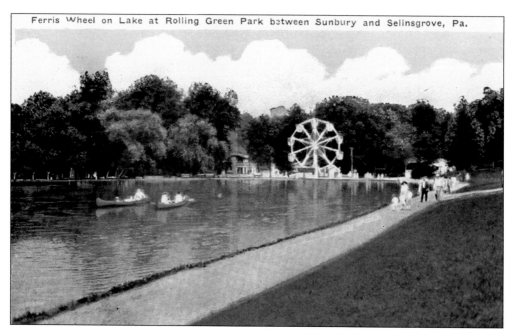

Ferris Wheel on Lake at Rolling Green Park between Sunbury and Selinsgrove, Pa.

It is not easy to hide a Ferris wheel, and no one tried at Rolling Green. The Ferris wheel was one of the park's earliest rides, and it remained quite popular as long as the park existed. It was a Packer Superior model and came to the park in 1924 (about the time of this card) by way of two special train cars. Folklore says it may still be in existence at Walt Disney World in Florida.

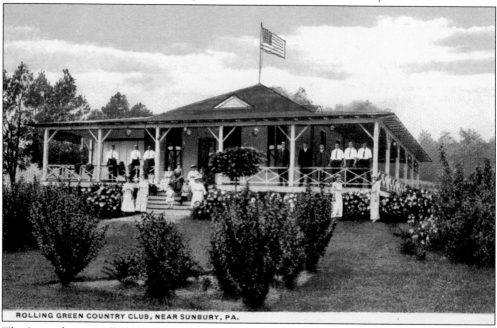

ROLLING GREEN COUNTRY CLUB, NEAR SUNBURY, PA.

The Susquehanna Valley Country Club, founded in 1914, was located adjacent to Rolling Green Park in Hummels Wharf. In 1923, the club built its stately, Spanish-influenced clubhouse for $41,000. The original clubhouse, seen in this World War I–era view, later became the home of the Roman Spangler family. Spangler purchased the park in 1935 after having managed it for a few years, and he continued as owner and operator through the 1960s.

46

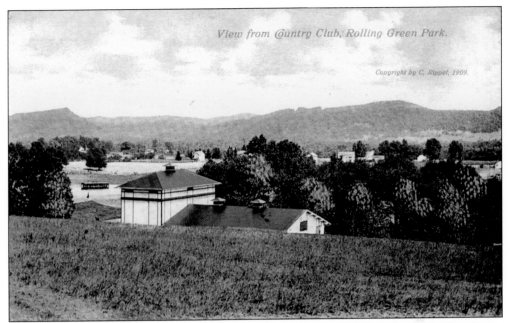

The view looking north from the Susquehanna Valley Country Club includes the Rolling Green Park theater, or at least its roofs. This card was produced by A. M. Deichler of Lancaster for Conrad Ripple of Sunbury. The view card includes a copyright date of 1909, so there is little doubt as to its vintage.

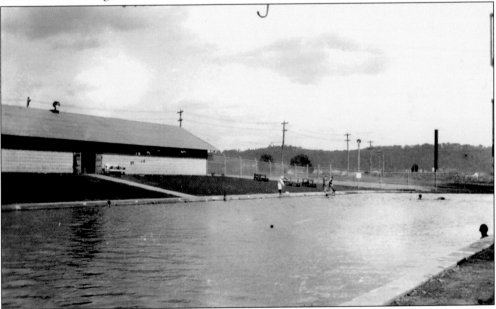

Thanks to documentation by a much appreciated (although unknown) "historian," we know this view of Rolling Green's swimming pool is from 1925, five years after its construction. A few heads appear above the water's surface, and a couple of would-be bathers are at the pool's edge, but there is little other activity. This was a "fill and draw" operation, meaning that the pool was filled and, after several days, the water was drawn out and the pool refilled. The process took place many times each summer.

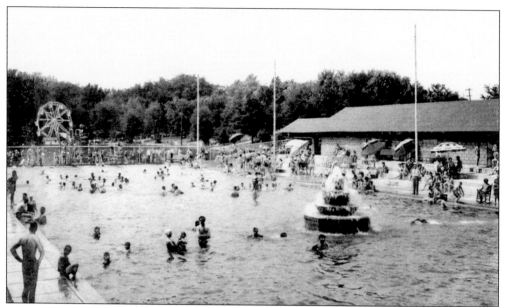

By the time of this *c.* 1941 view, a filtration plant had been added to the pool, eliminating the need to fill and draw. On hot summer days, especially weekends, Crystal Pool Private Swim Club was the place to be. Season tickets were available to all. Close inspection reveals a uniformed man in front of the pole at the right. His function is not known.

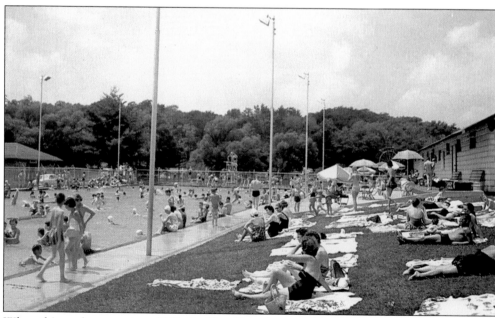

When this card was made *c.* 1962, Rolling Green's Crystal Pool was at its cynosure. Shortly thereafter, community pools sprang up, and crowds dwindled. The back of the card, an Ecktachrome by Joe Kast, mentions the "half-million gallon pool of filtered and aerated water." The filtration plant is seen to the left. Tanned, highly qualified lifeguards assured public safety.

Four

EATING AND SLEEPING ALONG THE TRAIL

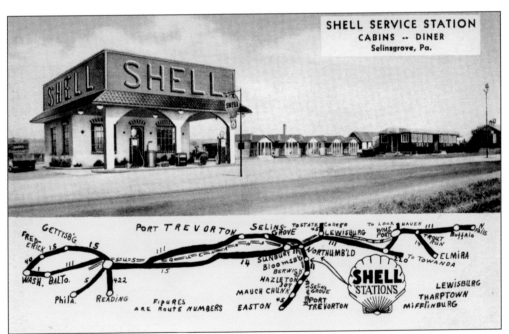

SHELL SERVICE STATION
CABINS -- DINER
Selinsgrove, Pa.

Of all the motels, gas stations, restaurants, and diners that have done business along the Susquehanna Trail, perhaps none was more enduring or more typical than the Shell Diner (the dark building at the right of the image). First established on the Old Trail, the Shell Diner was moved to the New Trail, or the Golden Strip, when Routes 11 and 15 changed course after World War II. The gas station and cabins were gone before Lowe's was built, but the diner remained as something of an institution.

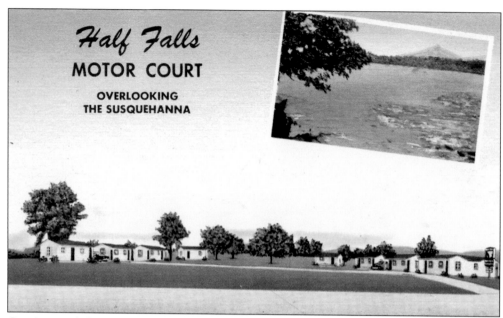

Coming north from Harrisburg, the first Snyder County motel one encountered was Half Falls Motor Court at McKees Half Falls. At the time this card was made in the mid-1950s, the motor court was operated by Dan and Ruth Freed and touted "central heating and a beautiful view." The description of the view was not exaggerated.

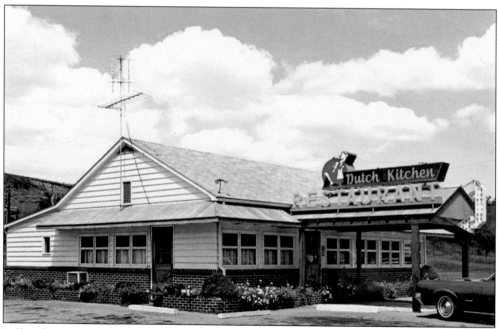

Folks of a certain age may remember a dispute between the Dutch Pantry and the Dutch Kitchen over the name of this restaurant in Port Trevorton RD No. 1. Chalk one up for the little guy; the Dutch Kitchen won and kept its name. Elsie K. Flanders was the owner at the time this card was made in the 1960s. The Dutch Kitchen featured home cooking and homemade pies. Though not in continuous operation, the Dutch Kitchen has remained open for business over the years.

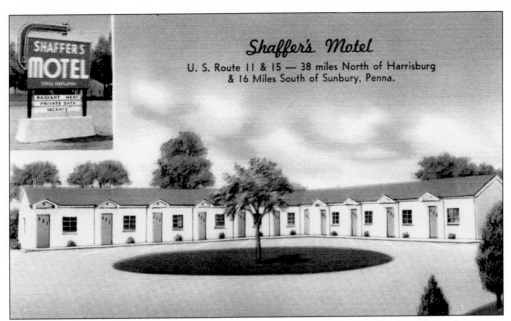

Shaffer's Motel

U. S. Route 11 & 15 — 38 miles North of Harrisburg
& 16 Miles South of Sunbury, Penna.

Another Susquehanna Trail motel in the Port Trevorton area was Shaffer's Motel. Due to competition, each motel had to trumpet its attributes; Shaffer's featured "Serta Perfect-Sleeper mattresses" and views of the Susquehanna Trail and Susquehanna River. This card was mailed on August 1, 1960, but it was printed in the mid-1950s, when Grant Shaffer owned the motel. These buildings no longer exist.

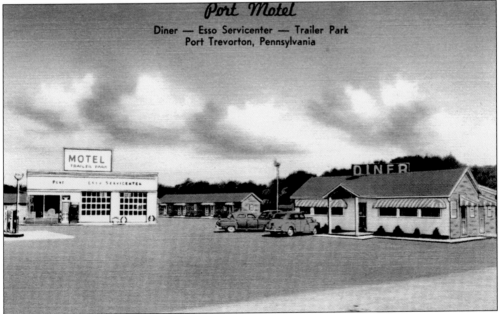

Port Motel

Diner — Esso Servicenter — Trailer Park
Port Trevorton, Pennsylvania

You could do it all at the Port Motel in Port Trevorton: eat, sleep, and get your car fueled and fixed at the Esso station. Built by G. Flanders Keller in 1952 and managed by George "Ducky" Sechrist, the Port Motel was a beacon to hungry, weary travelers. The landscape has changed somewhat, but the motel, along with storage facilities, is still at the same Susquehanna Trail location.

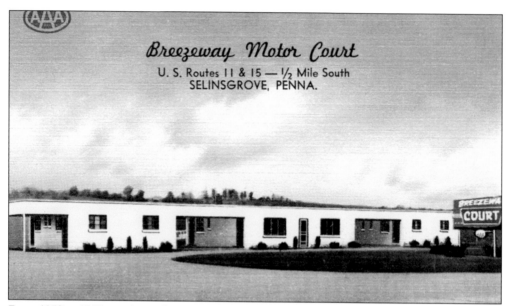

Breezeway Motor Court

U. S. Routes 11 & 15 — ½ Mile South
SELINSGROVE, PENNA.

From 1952 to 1958, music teacher June Hoke and her husband, Wilmer, operated the Breezeway Motor Court south of Selinsgrove. While negotiating the purchase of the Dutch Pantry chain for Kentucky Fried Chicken, Col. Harlan Sanders stayed at the motel and enjoyed a special breakfast of milk toast. Baseball Hall of Famer Frank "Home Run" Baker, going to and from Cooperstown, New York, also stayed here. Wilmer said, "Don't forget Jack the Blanket Man"—an institution for years at the Selinsgrove Fair.

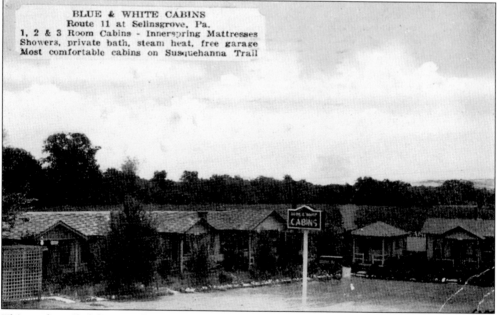

BLUE & WHITE CABINS
Route 11 at Selinsgrove, Pa.
1, 2 & 3 Room Cabins - Innerspring Mattresses
Showers, private bath, steam heat, free garage
Most comfortable cabins on Susquehanna Trail

This card, mailed from Williamsport on June 18, 1939, shows tourist cabins at the south end of Selinsgrove in the vicinity of the Selinsgrove Speedway. They are billed as "the most comfortable cabins on the Susquehanna Trail." The cabins had one, two, or three rooms and "a free garage." During the 1960s, this was known as Sleepy Hollow, and adventurous Susquehanna University students resided there. The far left cabin remains today.

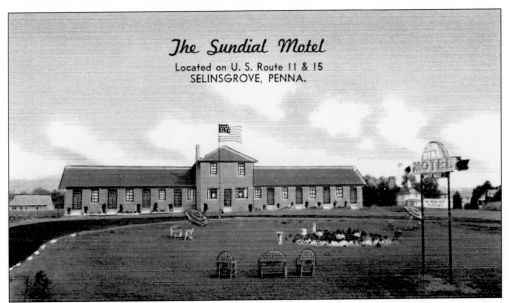

The first motel north of Selinsgrove, located just across the Penns Creek bridge, was the Sundial, which displayed a sundial in the middle of its spacious green lawn. In its heyday in the mid-1950s, when this card was made, the Sundial was as up to date as any other motel. It featured steam heat, free heated garages, and fully insulated, cross-ventilated, 14-by-24-foot rooms. The proprietors at the time were Mr. and Mrs. Lewis Paulhamus. Today, the building provides low-cost housing.

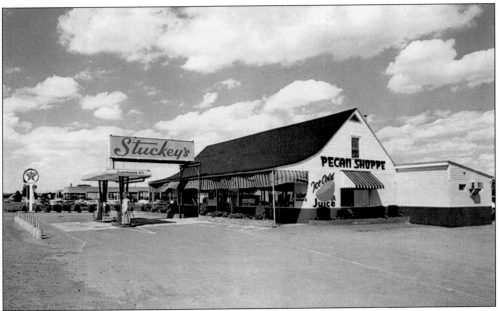

Well known throughout the South, Stuckey's Pecan Shoppe caused quite a stir when it opened a franchise just north of Selinsgrove in the early 1950s. According to the card, the store was "located on the beautiful Susquehanna Trail." The gift and souvenir store boasted "the South's finest candies and tropical jellies." The pecan log was the store's hallmark product. The building is now part of the Paul Stine Chevrolet complex.

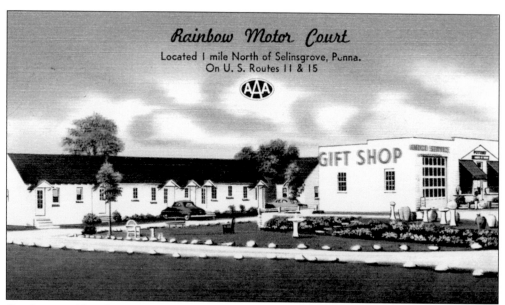

Rainbow Motor Court

Located 1 mile North of Selinsgrove, Penna.
On U. S. Routes 11 & 15

GIFT SHOP

On the west side of Routes 11 and 15, a mile north of Selinsgrove, the Rainbow Motor Court was another typical post–World War II motel. Approved by AAA, the motel was owned by Mr. and Mrs. George Downing at the time this card was made. Its rooms featured Simmons mattresses and free radios. The motel had no attached eatery, but the card notes "good restaurants nearby." In the 1960s, the original office building enjoyed great popularity as Keeney's Pancake House. It has been expanded into a Comfort Inn, which now has a restaurant and bar.

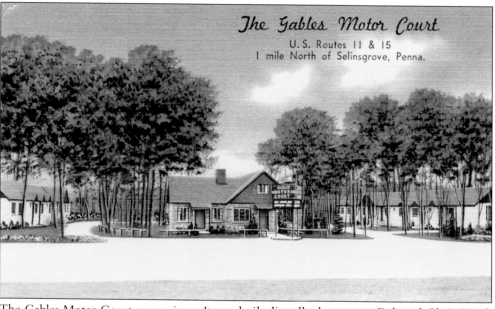

The Gables Motor Court

U. S. Routes 11 & 15
1 mile North of Selinsgrove, Penna.

The Gables Motor Court was unique. It was built, literally, by owners Bob and Chris Reed. They started building in 1946, but the motel did not open until 1949, missing its chance to be the first on the trail. Nevertheless, the quaint motel, whose office was built from stone taken from Shade Mountain and whose cabins were paneled with white pine from a Globe Mills barn, did a robust business through 1968. An antique shop was also part of the operation. The Swineford National Bank, located north of the Susquehanna Valley Mall, stands on the property today.

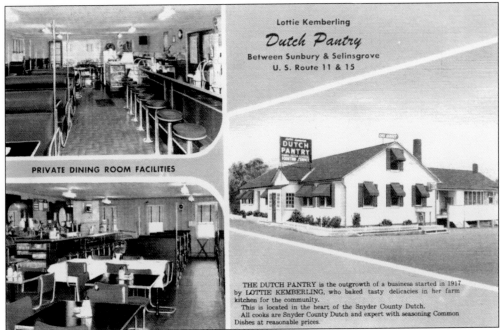

Lottie Kemberling began what would become a thriving business in 1917, making "tasty delicacies in her farm kitchen." Later, her son Jess opened the Dutch Pantry, pictured here in the postwar 1940s. Still later, this became the flagship restaurant for a chain that stretched as far south as Florida. Eventually, the chain was purchased by Kentucky Fried Chicken (see page 52). The card notes that "all cooks are Snyder County Dutch." The 4 Seasons Family Restaurant now operates at Hummels Wharf.

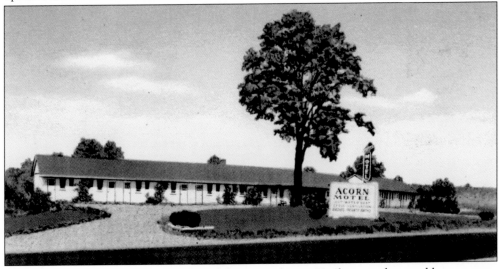

Entering the Shamokin Dam portion of the Susquehanna Trail, a traveler would come upon the Acorn Motel on the west side of the three-lane highway. The motel was opened in the 1950s and was owned by Howard D. Schnure. In addition to 15 units with private baths, it featured an outdoor fireplace and a playground. The motel operated until the 1970s, although some units were taken down to make way for a car wash. The space is now occupied by Don Pontius's Autos Plus.

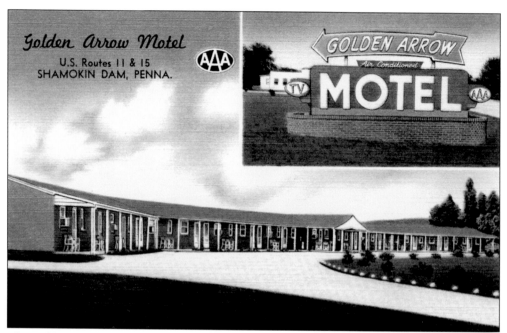

The Golden Arrow Motel remained notable for its hearty and reasonable breakfasts until recently. The Shamokin Dam facility was cutting edge in the 1950s; it had a television in each room! It was also air-conditioned rather than cross-ventilated. The cabins remain today at the rear of the lot, but the restaurant has made way for Auto Zone and Arby's.

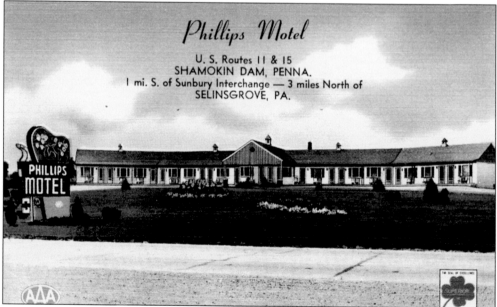

The Phillips Motel was one of the very first to open along the trail after World War II. While much enlarged, it still features an elaborate sign and country charm. Claiming that it is "as nice as any chain," Bucknell and Susquehanna parents make longstanding reservations for parents' day, homecoming, and graduation. Opened by Mr. and Mrs. Ray Phillips, it is now operated by the Goshorn family, owners since 1963.

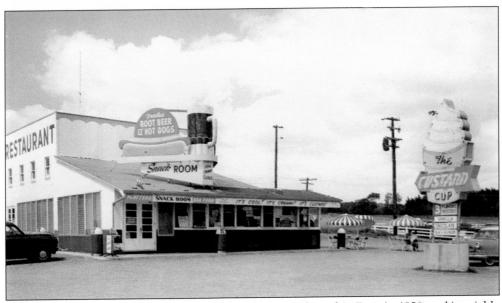

Rev. and Mrs. Frank Ulrich opened the Custard Cup in Shamokin Dam in 1950, and it quickly became a hit. Soft serve was somewhat new and not readily available. The frosted-mug root beer and foot-long hotdogs only added to the operation's popularity. A Pig's Dinner—an enhanced banana split—was a challenge to any appetite. Those finishing got a button attesting to their eating prowess. The Custard Cup closed in 1968, and a family practice medical facility now occupies the location.

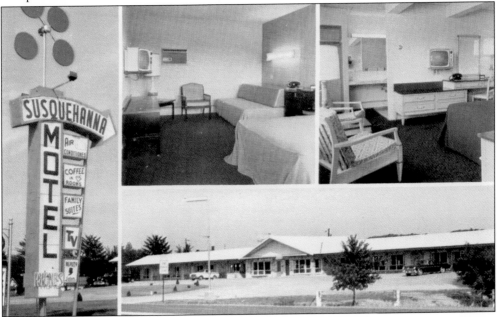

James and Rita Hepler were the owners and operators of the Susquehanna Motel, shown here c. 1962. Calling itself "the area's finest," the Susquehanna had 63 ultramodern units, much more than most motels at the time. Other enticements included free coffee, televisions, room phones, and a beauty salon. The motel is no longer in existence, and Aldi's Supermarket is located at the site in Shamokin Dam.

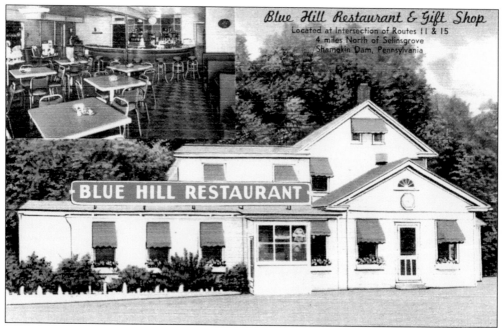

Blue Hill Restaurant & Gift Shop
Located at Intersection of Routes 11 & 15
4 miles North of Selinsgrove
Shamokin Dam, Pennsylvania

Ray and Gussie Watkins owned and operated the Blue Hill Restaurant, located at the split of Routes 11 and 15, into the 1960s. The bar (inset) was called the If Room and featured a framed print of a hunting dog. The Blue Hill served breakfast, lunch, and dinner; seafood, steaks, and homemade pastries were specialties. Tedd Skotedis took over the operation in October 1962. He and his family have overseen Tedd's Landing ever since, remodeling and expanding the establishment, while consistently providing quality meals.

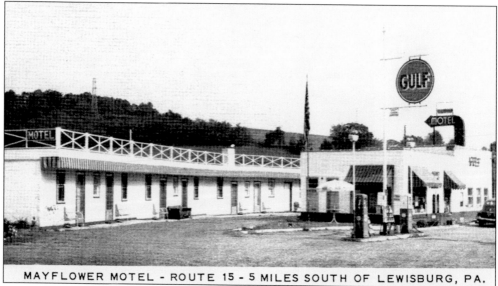

MAYFLOWER MOTEL - ROUTE 15 - 5 MILES SOUTH OF LEWISBURG, PA.

Located along Route 15 toward Lewisburg, a few miles north of the split of Routes 11 and 15, is the site of the former Mayflower Motel. Operated by Andy Loss, the complex was a motel, a Gulf service station, and a restaurant and bar. Business was brisk, but it really exploded in the mid-1960s, when the area's first and only go-go dancers appeared in the bar. The buildings stood in the vicinity of the Upholstery Shop.

Five

AHEAD OF THE
LEARNING CURVE

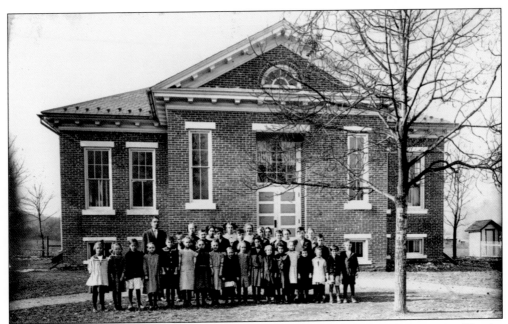

Larger and more modern than the many one-room schools located throughout much of Snyder County, the Kreamer School, seen here *c.* 1919, was slightly ahead of its time. Smaller one-room schools were in use in the county until the 1950s. Given the size of the building and the size of the group, it is unlikely that this represents the entire student body. There appear to be three teachers—one man and two women—so this image may represent the first three grades. The building, located at Freeburg Road and Vine Street, was taken down some years ago.

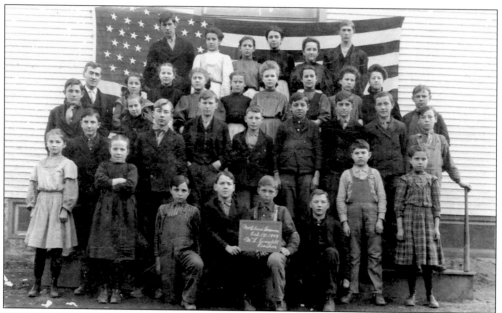

With a 46-star American flag (New Mexico and Arizona were not admitted to the union until 1912) as a partial backdrop, Mr. M. L. Graybill's pupils at the McClure Grammar School line up for picture day on Thursday, February 18, 1909. We know this information thanks to the slate held by two boys in the front row. We do not, however, know the students' names. Note the boy in the second row at the far right who appears to be ready for "spring training."

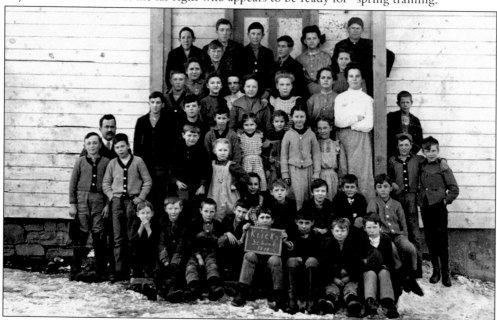

The slate tells us this is Krick's School in the winter of 1910. Judging from the snow, it is probably January, February, or March, a popular time for school pictures. The teacher is at the left in the second row, behind two boys wearing similar sweaters. One pupil is likely John S. Goss, as his name is on the back of the photograph. The exact West End location of the school is not known, but pupils from both Snyder and Mifflin Counties attended Krick's.

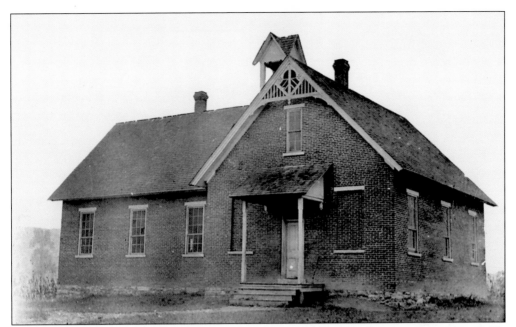

This photo postcard, produced by Horton Photography, depicts the two-room Troxelville Primary and Grammar School in 1908. Many former students still remember "dear old Golden Rule days." One is Mabel Bingaman Smith, who provided this card. She attended this school through eighth grade. The school was later converted into a residence.

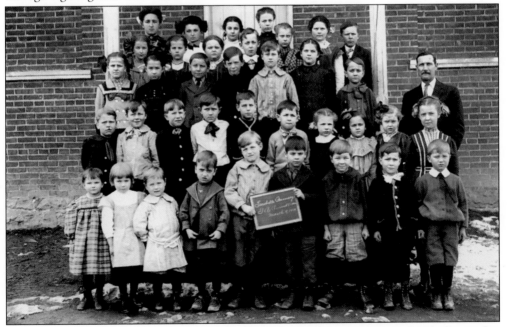

This is a primary-school group at the Troxelville school. The ever-present slate indicates that the date is March 9, 1911, and that G. A. Aurand is the teacher. He is behind two youngsters at the right. Schools such as this one were an outgrowth of the Free School Act of 1834. At first, school terms were short, from two to four months. It was not until 1922 that Pennsylvania schools adopted an eight-month term.

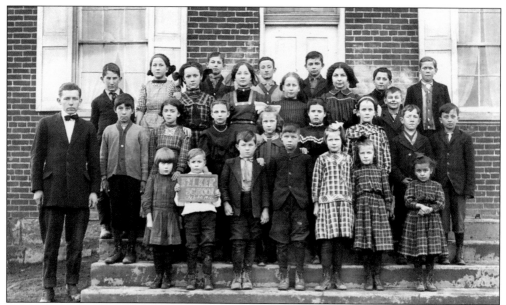

The elaborately lettered slate tells us that this is the Felker School, located two miles west of Beaver Springs. The youngster holding the slate, Paul Fry, seems to be taking the task seriously. Picture day was Tuesday, February 20, 1912. Information on the back of the image identifies the young, bow-tied teacher as Jay L. Spangler. In the earliest days, schools taught boys spelling, reading, writing, and arithmetic, but girls learned only spelling and reading.

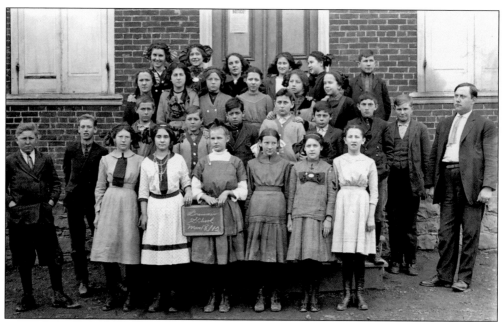

On Monday, March 18, 1912, this grammar school student body posed for its annual photograph. While the slate does not name the specific school, we do know that it was in the Beaver Springs area. The unidentified teacher is to the right of the students. He, like other teachers, was most likely subjected to the tradition of being "barred" or "penned out" by mischievous students on Shrove Tuesday, the last day before the start of Lent.

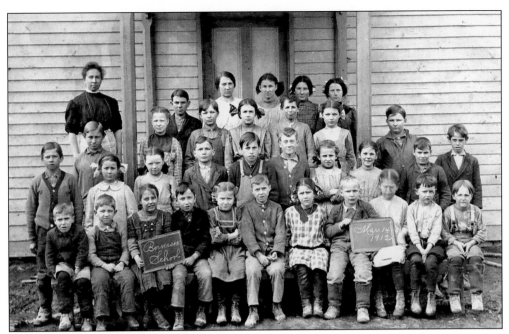

Two slates tell us the name of this West End school, Bowersox, and the date, Thursday, March 14, 1912. A look at the muddy shoes and boots lends credence to grandparents' tales of walking miles to school through rain, mud, and snow.

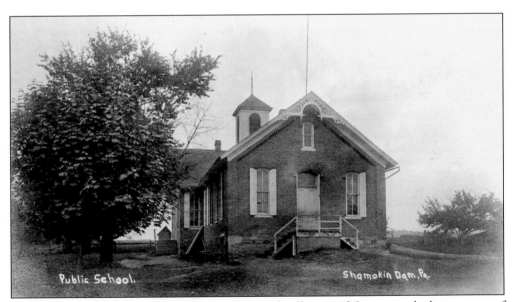

By the first two decades of the 20th century, nearly all areas of the county had some type of school. The Shamokin Dam Public School, shown here *c.* 1913, was somewhat different from the typical one-room schoolhouse. The school was located between the Old Trail and the New Trail near present-day Eyeland. To get an idea of what an early Snyder County one-room school was like, visit the restored Herman's School in the Kratzerville-Salem area.

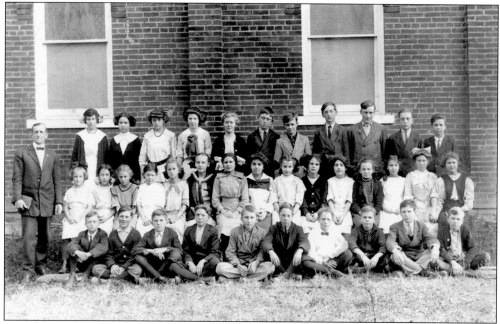

The students of the Shamokin Dam school and their textbook-toting teacher (left) pose for posterity *c.* 1924. The school seen here does not seem to be the same building as was seen on the previous page; a clue is found in the configuration of the windows. Students could refuse to take a class; their parents, not the teacher, decided the curriculum.

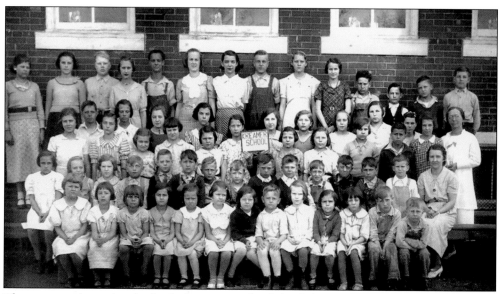

There seems to be no dearth of real-photo postcards of school photographs. Most, however, are from the earliest years of the 20th century. What makes this photograph of the Kreamer School student body different is the date, 1935, which is 20 to 30 years later than most other postcards of school photographs. The author hopes that a reader may help to identify the students pictured here.

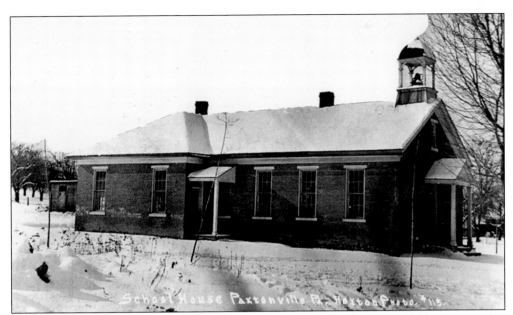

This real-photo postcard (Horton Photograph No. 115) is of the Paxtonville school. It is somewhat unorthodox; a good portion of the background has been airbrushed away. This is a typical one-room school, but it features an addition. The card was mailed from Paxtonville on January 20, 1908, to Elda Graybill, the sender's sister, at Medico Hospital in Philadelphia. She could have been a patient but was more likely a nursing student.

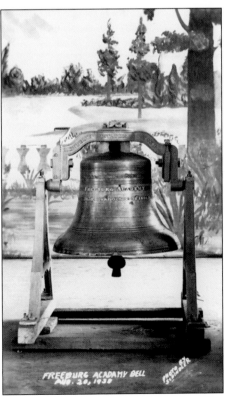

The Freeburg Academy, opened in 1853, was educationally significant in Snyder County. It burned on October 13, 1855, but it was quickly rebuilt and operated again from 1856 to 1908. The bell is one of the only meaningful relics from the school, and it has become symbolic of Freeburg. The 900-pound bell was cast at the Meneely Foundry in West Troy, New York, in 1856. When the academy closed, the bell was moved several times, but Arthur C. Brown, a former student, brought it back to town.

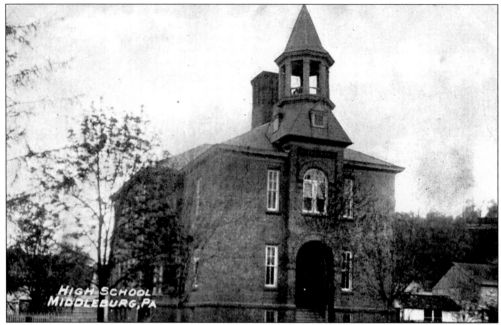

When Middleburg High School was built at 13 North Main Street at the turn of the century, the stones used for the foundation were taken from the dismantled Beaver Furnace, an early iron ore smelter in Paxtonville—much to the chagrin of later historians. The school served from 1899 to 1925 and now houses the borough offices. Middleburg High School was moved to a new building on South Main Street, which was dedicated by Gov. Gifford Pinchot on September 19, 1925. Recently, the district merged with West Snyder to form Midd-West.

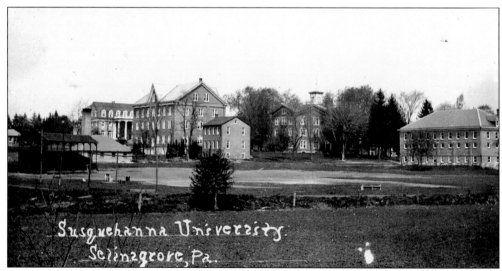

This 1909 view of Susquehanna University encompasses nearly all of the buildings on the "broad campus." Behind the baseball field and grandstand are, from left to right, Seibert Hall, Gustavus Adophus Hall, a smaller building of undetermined use, Selinsgrove Hall, and the Alumni Gym, which burned down and was replaced in 1935. Gustavus Adophus Hall fell victim to fire late on the night of November 19, 1964. Bricks for the early buildings were made by Jackson Gaugler, who accepted a music scholarship for his daughter as partial payment.

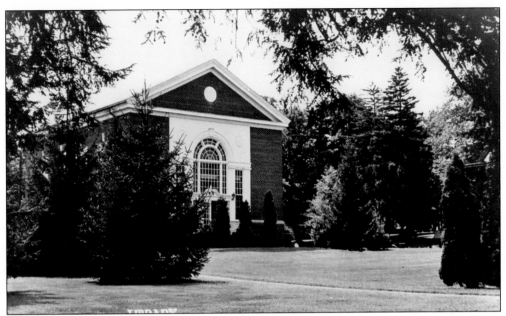

The library at Susquehanna was built in 1928, at the start of G. Morris Smith's tenure as president. This photograph was taken in 1954, five years before the end of Smith's academic career. In the early 1960s, the library was incorporated into a much larger building that is now known as the Blough-Weis Learning Center. By that time, the university was under the dynamic leadership of Dr. Gustave W. Weber.

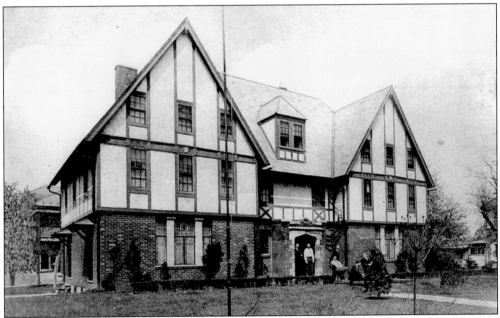

Dedicated on January 19, 1928, the same year as the library, Phi Mu Delta fraternity, with its Tudor architecture, is a classic college building. It was the first Susquehanna fraternity house built for that express purpose, and it cost $40,000. The University Avenue property fell into disrepair and eventually fell victim to fire in 1992. Another Phi Mu Delta house, closely duplicating the original, was built on the upper campus in 1987.

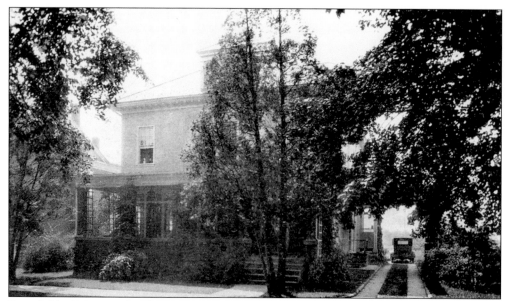

Founded in 1927, Bond and Key earned a reputation as one of the nation's best local fraternities. Most Selinsgrove SU students who "went Greek" joined Bond and Key. Bob Moser, who wrote radio scripts for *Amos 'n' Andy*, worked the Bond and Key ritual into the show's Mystic Knights of the Sea ceremony. The local fraternity eventually went national in 1956, affiliating with Lambda Chi Alpha. When a new chapter house was built on the upper campus, the old house, shown here *c.* 1934, became the Kappa Delta sorority house.

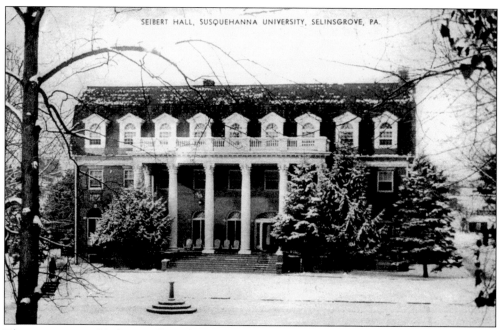

The cornerstone of Seibert Hall was laid on November 26, 1901, and the building was completed in 1902. The years have not dulled its classic beauty. Here, a fresh coating of snow only enhances its appearance. Extensively renovated in the 1970s, Seibert remains Susquehanna University's architectural signature.

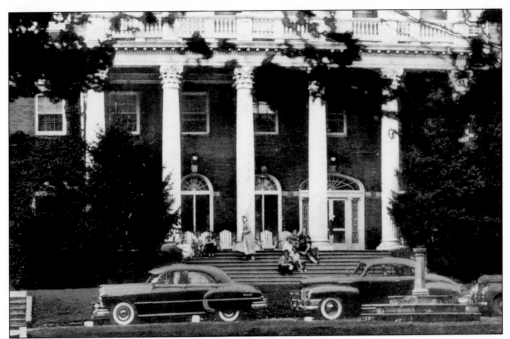

This 1950s card of Susquehanna University's Seibert Hall was produced in two versions, black and white and hand-colored. Both versions capture the building's timeless beauty and stateliness. Once a girls' dorm, dining hall, and chapel-auditorium, Seibert Hall now serves the university as a multipurpose facility. The three cars represent the 1950s, 1940s, and 1930s, though unintentionally.

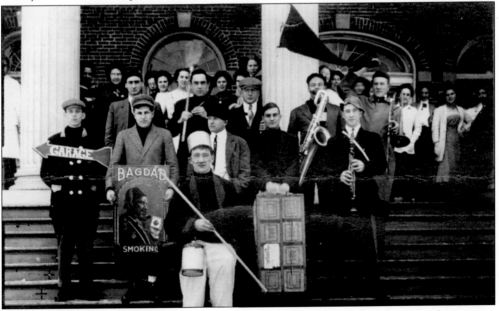

A liberal education includes more than just classes, laboratories, and studying, as these young men and women of Susquehanna University illustrate. The occasion is unknown. The card, mailed in Selinsgrove on October 12, 1912, is proof of efficient mail delivery and train service. The sender, Guy, confidently tells T. J. Middleswarth of Yeagertown that he will be "up there this evening on the late train."

Shown is a pre-1907 card, permitting only an address on the back, from a College Girl series. There were many such series, but they were usually limited to Ivy League colleges and other major universities, such as Michigan, Chicago, Army, and Navy. While many of the schools were all-male, Susquehanna had been coed since 1895. The card features SU's unique school colors, orange and maroon.

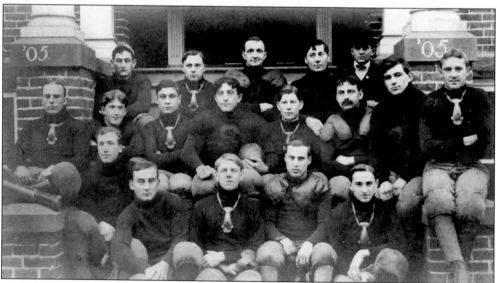

Athletics, especially football, have always been a target for educational reformers. Others contend that a college education that does not allow for athletic activity is not complete. Regardless, football has survived, but not without a fight. Football had become so brutal that in 1905, when this postcard of Susquehanna University's team was produced, Pres. Teddy Roosevelt said, "Clean it up or desist." In 1906, the forward pass was legalized. Selinsgrove's Foster Benfer (third from the left in the front row) was the starting quarterback.

Six

FAMILY VALUES

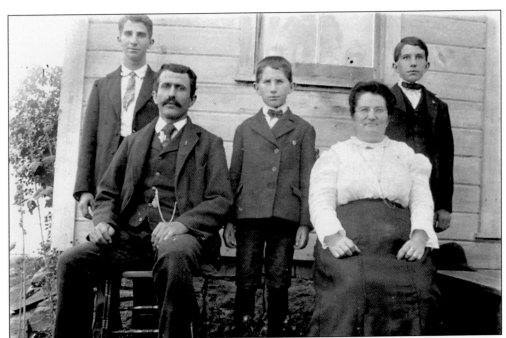

Family ties and family values have meant much to Snyder County residents down through the years. Most activities still center around the family. There is not much to identify the West End family seen in this *c.* 1914 image; all that is written on the back of the card is "P. S. Mitchell." Interestingly, the same cursive script identifies Beaver Springs bandmaster Palmer S. Mitchell on the card on page 28. Could one of these youngsters be the famous Music Man?

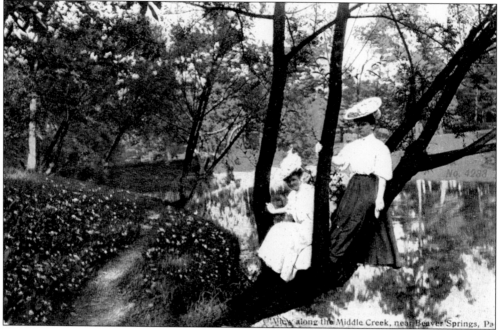

Pictured on this post-1907 card are, perhaps, two sisters in their "Sunday go to meeting" dresses and millinery. Imprinted on this hand-tinted card is "View along Middle Creek, near Beaver Springs, Pa." Although many color cards of the first decade of the 20th century were printed in Germany and Great Britain, this one appears to have been printed in the United States.

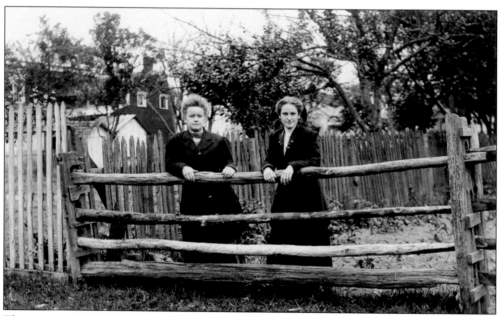

The anonymous photographer of this real-photo postcard really knew his business. The composition is outstanding, and the sharpness of the image is unquestionable. While the only helpful note on the back is "Beaver Springs," we might assume the young ladies are sisters. Their attire suggests the card was produced c. 1910.

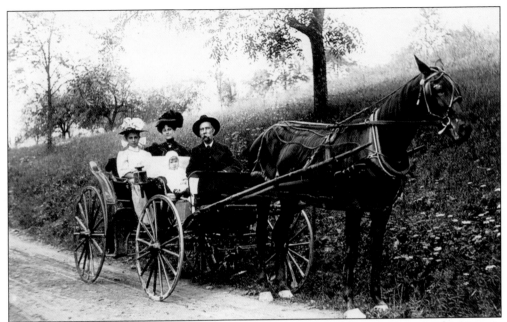

This Middleburg area family is unidentified, but that does not diminish the value of this real-photo postcard. This sharp *c.* 1909 image provides a clear picture of this family: their dress, their expressions, their means of conveyance. The photographer, D. W. Clotfelter, was highly skilled.

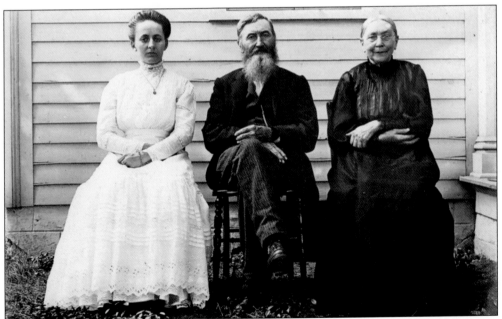

There is true significance to this pre-1907 real-photo postcard. It is most likely from 1906 and shows a young Minnie Steeley and her uncle and aunt, Mr. and Mrs. Reuben Smith of Bannerville. That year, Minnie was working on the staff of Ammon M. Aurand's Beaver Springs *Herald*. She related, "At the time of the [Beaver Springs] Centennial [1906], I helped set type for the Centennial book. My wages were three cents an hour."

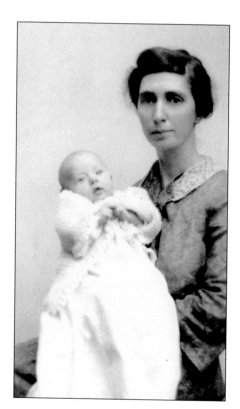

In addition to working in the printing office of the Beaver Springs *Herald* in the early days of the 20th century, Minnie Steeley was an oft-seen and well-known figure about Middleburg, especially in her later years. Though she never married, Minnie had great affection for youngsters. She is shown *c.* 1926 with an unidentified infant. The only notation is "3 months old."

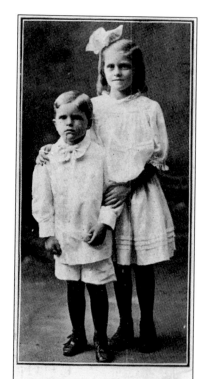

CARRIE AND ALTON AURAND, Beaver Springs, Pa.

These handsome youngsters, Alton (left) and Carrie Aurand, are the nephew and niece of Ammon M. Aurand. For many years, beginning in 1887 and continuing until 1923, Ammon Aurand operated the Beaver Springs Herald Printing and Publishing Company. In addition to this card, he produced a series of several view cards *c.* 1905, some of which are seen elsewhere in this book. The *Herald* enjoyed one of the largest weekly circulations in central Pennsylvania.

Before "family values" became a catchphrase in the late 20th century, the term was very meaningful to Snyder County residents. Perhaps nothing symbolizes family values more than our churches. The house of worship pictured here was erected in Beaver Springs in 1884. Over the years, the church, shown in 1903, became known as Christ Church. The highly respected Rev. Herbert B. Zechman served 20 years, from November 1938 to September 1958, in Beaver Springs, Troxelville, and four other area churches.

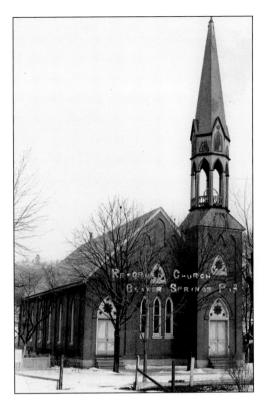

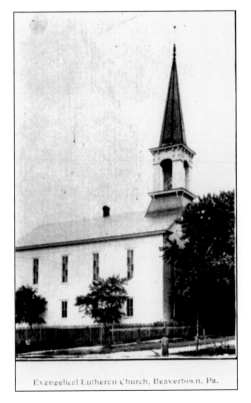

Evangelical Lutheran Church. Beavertown. Pa.

By comparing this pre-1907 card to others in the collection, we can determine that it was produced by the printing operation of Ammon M. Aurand's Beaver Springs Herald Printing and Publishing Company. The newspaperman and printer put out a multicard series in the early 1900s. Shown c. 1905 is the Evangelical Lutheran Church of Beavertown.

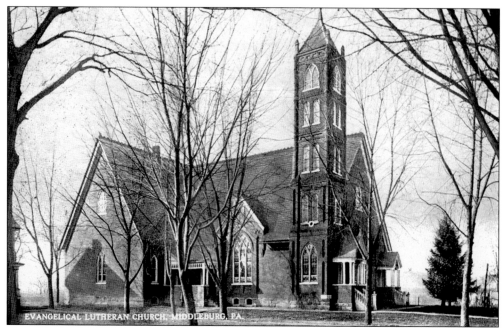

This *c.* 1932 A. E. Snook card identifies this church as the Evangelical Lutheran Church, which was first organized in Middleburg in 1833. It is more commonly known as the Emmanuel Lutheran Church. This building was dedicated on Sunday, April 23, 1893. During the depths of the Great Depression, the Emergency Players performed biblical dramas for free-will offerings, which helped sustain the church. A fire destroyed the church on December 28, 1952. A new church, dedicated on June 7, 1955, was built at the same location and stands today.

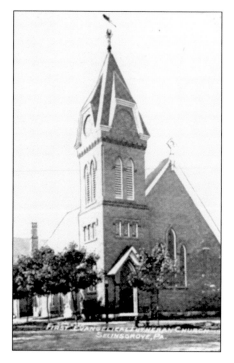

The First Lutheran Church of Selinsgrove, shown in 1906, can trace its origins back to 1803, when it was organized as the Sharon Lutheran and Reformed Church. Later, the Reformed group separated from the church. Still later (1843), another Lutheran church, Trinity, was organized in town. The two Lutheran churches merged under the original name, Sharon, on December 20, 1971. The church, which has been somewhat renovated, still occupies the corner of Market and Bough Streets.

Trinity Lutheran Church, located in the 100 block of South Market Street in Selinsgrove, was first organized in 1843. The two parking meters tell us that this card was produced in the mid-1950s. When First Lutheran and Trinity merged in December 1971 to form Sharon Lutheran, using the existing First Lutheran building, the Trinity building became available. The Lafayette Lodge No. 194 of the Free and Accepted Masons took over and renovated the building to serve as its lodge hall.

The title of the card is "Water St., Selins Grove, Pa." The most prominent feature on this 1909 postcard is the First Methodist Church, built in 1858. If one looks hard enough at the middle of the card, the streetlight that illuminates the intersection of Pine and Water Streets can be seen. Another Methodist church was built on Rhoads Avenue in 1965, and this church became a center for senior citizens.

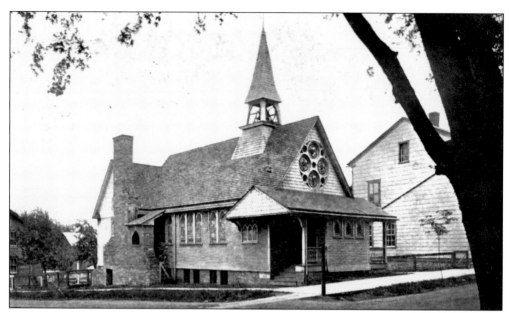

Perhaps one of the most underrepresented denominations in Snyder County is the Episcopal church. Nevertheless, the cornerstone of All Saints Episcopal Church was laid in 1899. The church, shown here in 1909, is located at the corner of Market and Snyder Streets in Selinsgrove. It was recently refurbished and expanded. Mary Kiterra Snyder, granddaughter of Simon Snyder, was most generous to All Saints through her will.

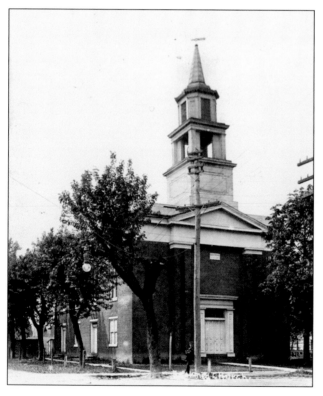

St. Paul's United Church of Christ, located at Market and Mill Streets in Selinsgrove, was first part of Sharon Lutheran Church. A cornerstone for that church was laid on Tuesday, June 7, 1803. Earlier, in 1787, Selinsgrove founder Anthony Selin gave land at Pine and High Streets for a German Reformed church, but it was never built. By 1855, the Reformed congregation, shown here in 1912, left Sharon and built its own church. The cornerstone was laid on August 18, 1855. On August 9, 1915, an addition was begun.

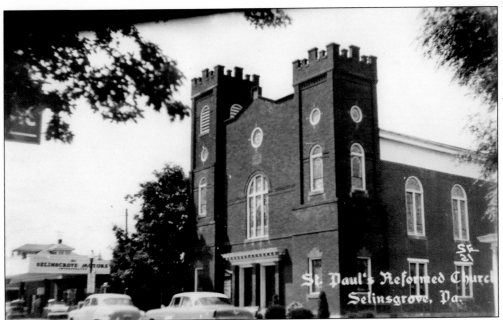

For people of a certain age, this 1957 image depicts how they first remember St. Paul's United Church of Christ, located at Market and Mill Streets in Selinsgrove. After the steeple was removed, the twin-towered addition was built in 1915. Behind the addition is most of the original 1855 church. In 1959, the same year that an educational building was built, the Reformed churches merged with the Congregational churches to form the United Church of Christ (UCC). Pastor Beth Voigt serves the growing congregation.

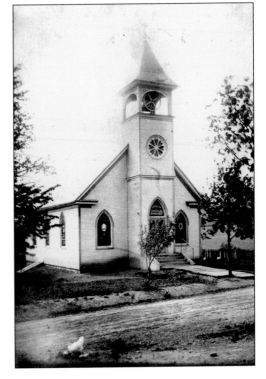

In Snyder County's smaller communities, the church was even more a center of family activity. The Verdilla Church was organized before 1840 on land donated by Jacob Keiser and became known as Keiser's Church. During World War I, when anything German-sounding was regarded negatively, the name was changed to St. Paul's Lutheran and Reformed, as it appears on this 1920s card. Today, St. Paul's is well known for its public chicken and waffle dinners, served outdoors, weather permitting.

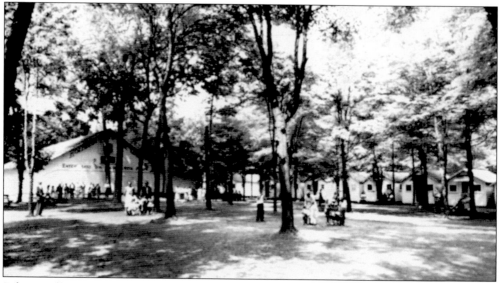

When God's Holiness Grove was first constructed c. 1930 along the S&S trolley tracks in Hummels Wharf, it quickly enjoyed great popularity. Shown in this 1940s card are the large assembly hall and the smaller cabins. Camp meetings were held several times a year and drew large crowds. When the site was sold recently, a rumor quickly circulated of a Red Lobster being built on the site, which is still not fully cleared. Many families purchased their cabins and had them moved rather than letting them be demolished.

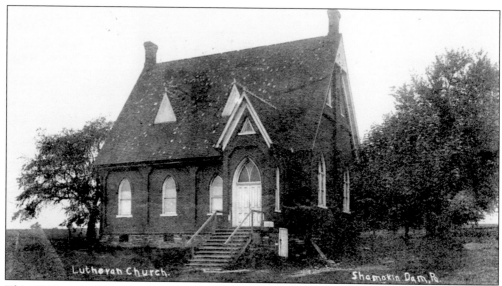

This 1907 card of St. Matthew's on the Old Trail in Shamokin Dam provides an example of the popularity of Lutheranism in the area. Early settlers were German, and their churches were Lutheran or German Reformed (UCC). Conrad Weiser, a tremendously important figure in the county's history, may or may not have been partial to German settlers, but very few Scots-Irish immigrants came to our county. While there are Presbyterian churches in all the surrounding counties (most Scots-Irish were Presbyterian), there was never one in Snyder County.

Seven

HOME SWEET HOME

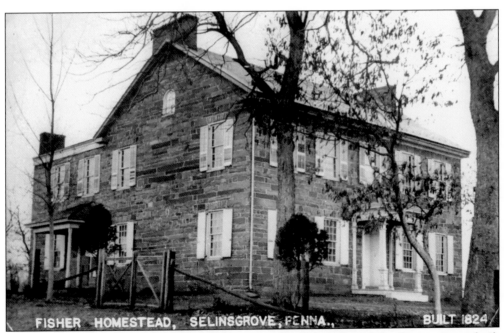

FISHER HOMESTEAD, SELINSGROVE, PENNA., BUILT 1824

This is one of the oldest and most historically significant houses in Snyder County. It was built in 1824 by George Fisher and is very much intact today. According to William M. Schnure's *A Chronology of Selinsgrove,* George Fisher, who was the son of John Adam Fisher, "built a stone house at the south end of the Isle of Que, near the old log grocery just south of the former location of Conrad Weiser's grain house." In the 1960s, George Burgard, a member of the legendary World War II Flying Tigers, lived here with his family.

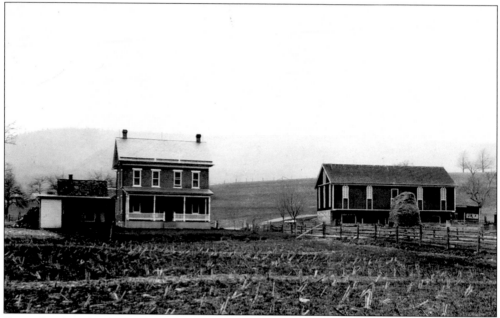

From the time Snyder County was first settled in the 1740s, residents engaged in farming. It has only been relatively recently that the majority of Snyder County residents have worked in activities other than agriculture. This is the Dave Woodling farm, located right outside of Troxelville on the road to Penns Creek, as it appeared in 1911.

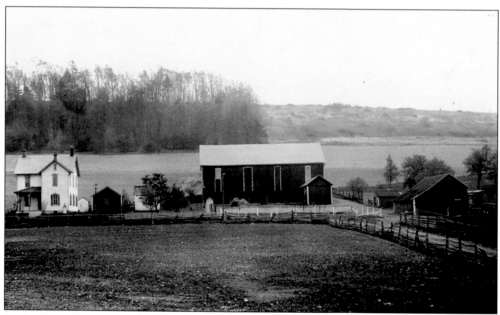

In the Pennsylvania Dutch tradition, Snyder County farms are well kept and maintained. In this West End farm photograph, which dates to 1910, the very small figure standing proudly in front of the house is probably the farmer's wife. County farmers organized as early as 1860, when the Snyder County Agriculture Society was formed. In October 1862, Middleburg outbid Kreamer, Freeburg, and Selinsgrove to host the first county fair.

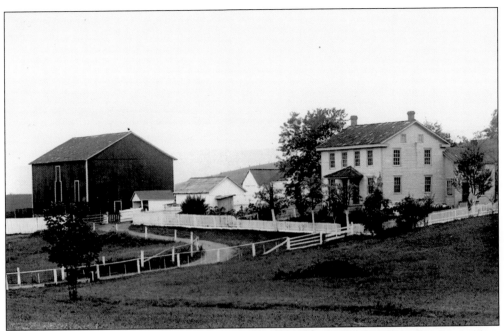

The owners of this property, Mr. and Mrs. J. Shirey, must have been very proud of their McClure farm buildings and land. It is hard to imagine a better maintained working farm. Note the lack of utility poles and wires in this and other farm photographs. The Shirey farm is shown here in 1909, well before rural electrification.

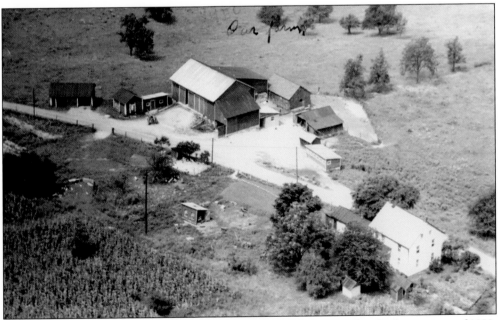

This aerial photograph of the J. Miles and Anna Kratzer farm was taken in the summer of 1950. Miles was born in the sturdy farmhouse on his father's farm in 1911, the year the house was built. He operated the 87-acre dairy farm all of his life and passed it on to his son Marlin and his wife, Mary. Marlin still operates the farm, which is situated at Middleburg RD No. 3.

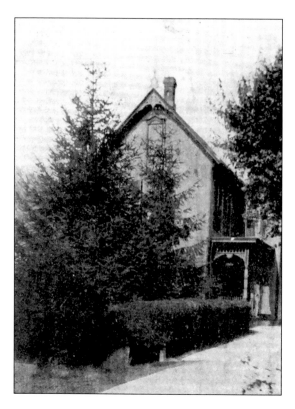

Perhaps only Gov. Simon Snyder was a more distinguished citizen of Snyder County than McClure resident Ner B. Middleswarth. Born in Scotland to German parents, Middleswarth came to central Pennsylvania in 1792. He was a captain of a company of volunteers in the War of 1812. Active in many business ventures, he was best known as the operator of Beaver Furnace, an iron ore smelter. He served twice as speaker of the state house, and he eventually served in the U.S. House of Representatives. This card dates from 1908.

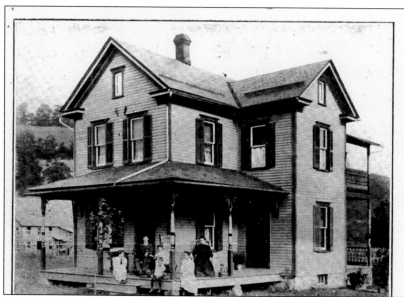

Residence of
T. H. Speigelmire
McClure, Penna.

Pictured *c.* 1909 are the residence and family of T. H. Speigelmire of McClure. Speigelmire was a businessman and civic leader. He is credited with developing Castolio soap, which was manufactured in McClure at a facility that eventually became Union Furniture. The soap included clay and sand and was billed as "a cold water soap good for cleaning, scouring, and polishing all kinds of metal, and can be used for cleaning teeth."

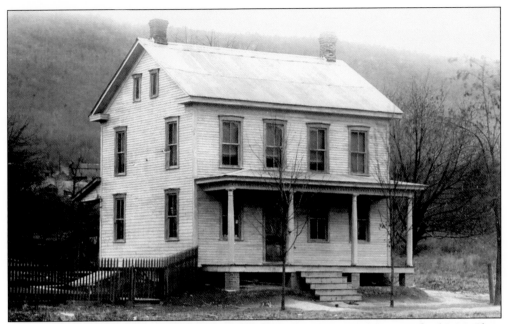

Like so many sturdy Snyder County homes built at or before the turn of the century, this McClure home, located on West Walker Street, is still standing. At the time this real-photo postcard was made *c.* 1913, this was the home of Cluny Arthur Baker, publisher of the McClure *Plain-Dealer.* It was later the home of Edna Young.

There is a lot of activity around "Uncle Jacob Dreese's home" in McClure in 1915. According to the sender, "this is a Bean Soup picture." She also tells Mrs. Levens Norman of Troxelville, "my little bonnet is light calico with little red dots." Judging from the dress of those pictured, they are about to go to the Bean Soup festivities.

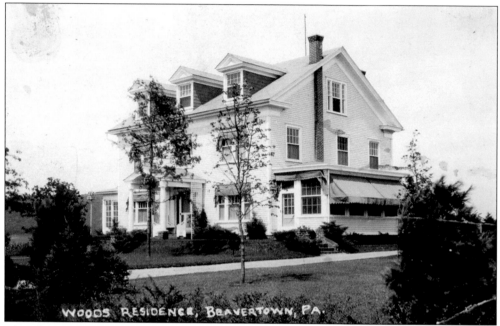

WOODS RESIDENCE, BEAVERTOWN, PA.

This elegant home in Beavertown was built in 1920 for the John S. Wood Jr. family. Wood operated several tanneries in the Snyder County area. The house was a wedding gift to Wood's wife, Mary, who continued to live there after his death in 1930. The Archibald family later lived there.

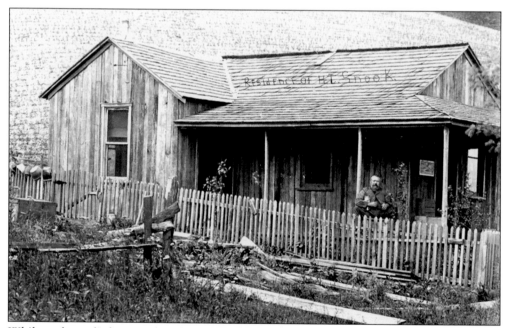

RESIDENCE OF H.T. Snook

While we know little more than that this is the "residence of H. T. Snook," this *c.* 1917 card has some interesting details. The robust Mr. Snook seems to be a feline fancier. A sign for Zig-Zag cigarette papers is affixed to the West End home (above Snook to the right), and there are five inverted crocks on the picket fence at the far left.

Shown in this card is D. A. Kern's residence, built in 1887. Kern was chief burgess of Middleburg in 1906, when this card was made. The home served as Dr. Joseph Potter's hospital from July 27, 1929, until 1934, when ill health forced Dr. Potter to close the facility. The building at 125 West Market Street has been the home of the family of Ron Troutman of Troutman's Meats since 1972.

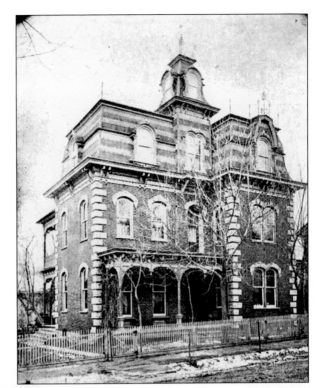

A question that cannot be answered is written on the back of this real-photo postcard. Directed to the sender's sister, it asks, "Do you know the doll baby in the middle of the road?" We know the card was mailed to Swineford in 1910, but we do not know the two women (who may be a mother and daughter) nor the unpaved street in Selinsgrove. The younger woman, perhaps the sender, appears to be holding a black-and-white cat.

At the time this card was sent on August 26, 1909, this was the home of Susquehanna University president Charles T. Aikens, who was affectionately called Prexy Aikens by the students. Aikens served as head of the university from 1905 to 1927, making great educational strides. After his death in 1928, his widow continued to reside in this house. Today the Broad Street and University Avenue property is the Alpha Delta Pi sorority house.

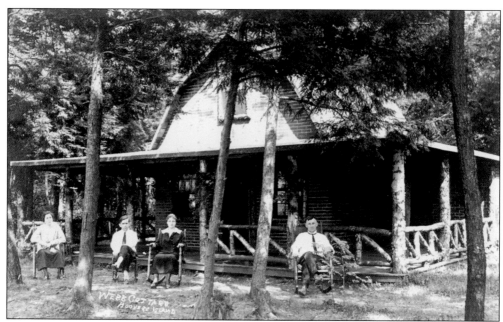

Hoover's Island, located in the Susquehanna River north of Port Trevorton, is about as far east as one can go in Snyder County (actually, the west bank of the river is the county's eastern boundary). Seen here *c.* 1913 is the Webb cottage on the island. Hoover's Island was big enough to have a school, a farm, and several vacation cottages. Though they are not identified, those pictured are presumed to be members of the Webb family.

Eight

PLANES AND BOATS
AND TRAINS

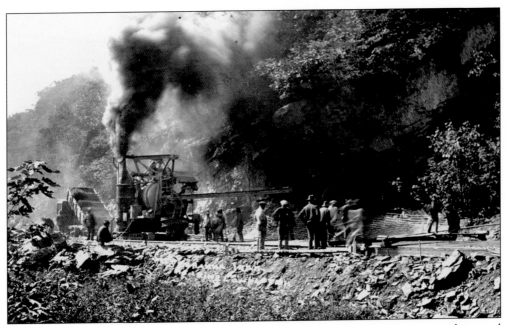

Work in Snyder County took on many forms. Perhaps none was more important than road building. A most important road is the Susquehanna Trail (Routes 11 and 15), a major north-south highway that winds along the Susquehanna River from the Mason-Dixon Line to the New York border. Here, a crew and machinery work on the final stages of the paved roadway along the Narrows section north of Port Trevorton. This section of road was completed on September 15, 1923.

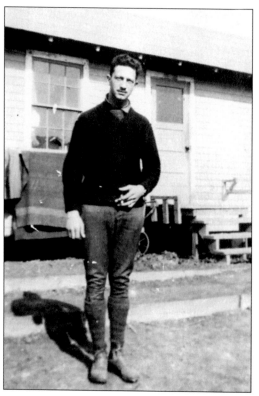

Although his airplane is not visible and he is not wearing his leather aviator's helmet or white silk scarf, many people will recognize World War I flyer Lt. Harold W. Follmer of Selinsgrove. Follmer, a close friend of "Ace of Aces" Capt. Eddie Rickenbacker, flew many combat missions—most likely with the 94th Aero Squadron, "Hat in the Ring." Follmer, working tirelessly behind the scenes, had much to do with George "Jack" Spaid (another aviation pioneer) being accepted into the Army Air Corps in 1930.

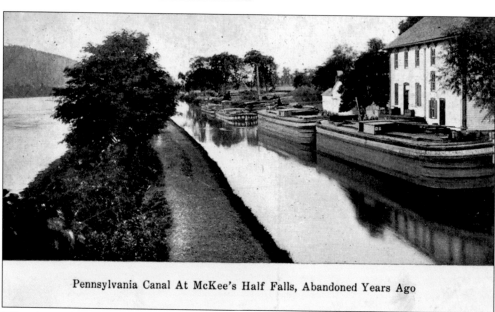

Pennsylvania Canal At McKee's Half Falls, Abandoned Years Ago

What is interesting about this card is that it shows just how close the Pennsylvania Canal is to the Susquehanna River. Note the size of the canal boats (80 by 14 by 8.5 feet) in relationship to nearby buildings. This card, postmarked August 20, 1908, reads, "Abandoned Years Ago," but the canal had been used until 1901, only seven years previously. With 1,356 miles of canals, Pennsylvania was the nation's mileage leader.

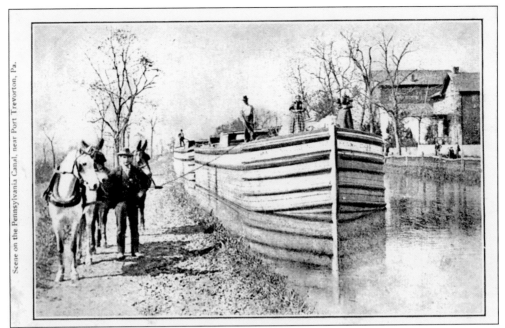

Scene on the Pennsylvania Canal, near Port Trevorton, Pa.

As in the rest of the United States, transportation in Snyder County consisted of more than planes and boats and trains. This Pennsylvania Canal photograph shows an early and important means of transport. It was taken near the Boatmen's Home at Port Trevorton in 1892, but the card was produced somewhat later. Also shown is J. N. Reiff, or Adam Reiff, tending mules on the towpath. Harry Mullner is at the rear of the barge. Boyer's Store (right) was later Reichenbach's and is now the home of the musical group Re-Creation.

The coming of the railroads signaled the end of the canal era. The last boat floated by in 1901. Judging from the looks of this lock, which was probably located near Port Trevorton, it did not take long for the waterway to fall into disrepair. The view of the lock provides an idea of how it operated. The card is postmarked "Mount Pleasant Mills, April 30, 1907."

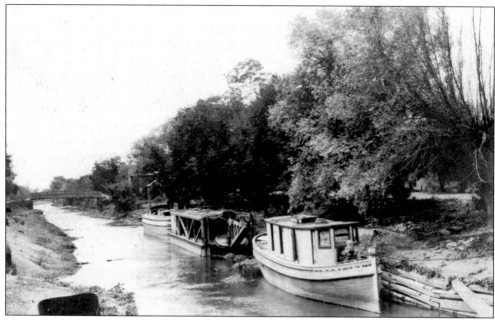

Not all canal boats were flat and measuring up to 80 feet in length and 14 feet in width. Here, much smaller boats are seen on the Pennsylvania Canal's Susquehanna Division at Shamokin Dam in 1908. By that time, the larger boats were no longer used. Note the covered bridge spanning the canal at the left.

VIEW OF PENN'S CREEK, SELINSGROVE, PA.

For much of its considerable length, Penns Creek, which begins in Penns Cave in Centre County, is quite shallow. The boatman shown at Selinsgrove is "poling" rather than using oars to row. Regardless of its depth, Penns Creek provided Snyder County residents with many benefits: transportation, recreation, and peaceful scenes such as the one seen in this *c.* 1921 image.

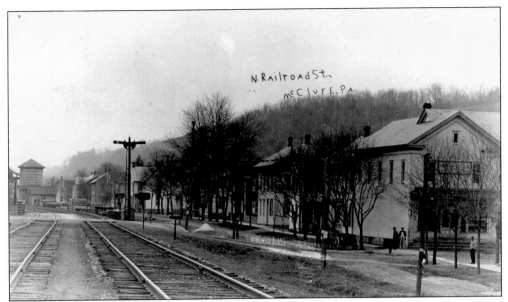

The Middle Creek Valley Railroad, later known as the Sunbury–Lewistown line, was completed through Snyder County in 1871. As stated earlier, the town of McClure was created in large measure for the railroad. This card is an example of deltiology, the collection and study of postcards. A McClure resident, identified only as J. K., sent this card to a fellow hobbyist in Ashland, Ohio, with the offer of "exchanging other views with you." The card is dated July 23, 1909, and is postmarked McClure.

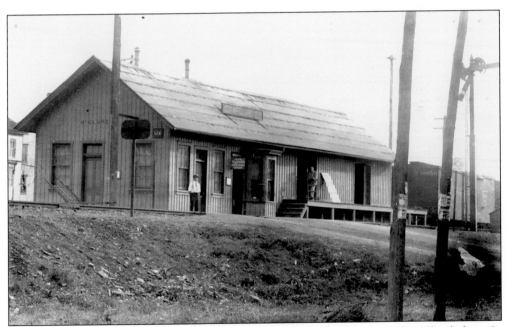

Once there were trains and passengers, depots were needed. This is a view of McClure's depot in 1911. A sign announces, "Postal Telegraph, Commercial Cables." Signs posted on the telephone poles advertise what this country needs but misses: a good 5¢ cigar! Opera Queen is the brand. Note the rather sophisticated signals at the far right.

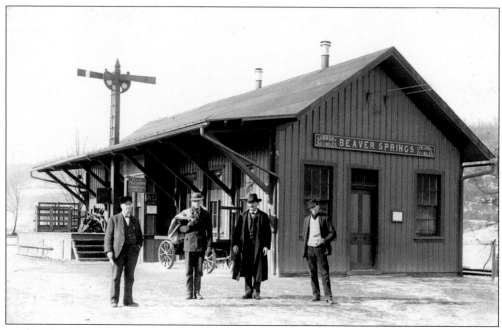

Farther along the line from McClure is the Beaver Springs depot. The railroad strove for accuracy as well as punctuality. The sign states, "Sunbury, 26 3/10th mi.; Lewistown Junction, 23 7/10th mi." The men appear to be, from left to right, a station attendant, a postal employee, a well-dressed passenger, and a youthful passenger. The sign on the door states, "Passenger Room." Kudos to the unknown photographer and his camera for an exceptionally sharp image, *c.* 1911.

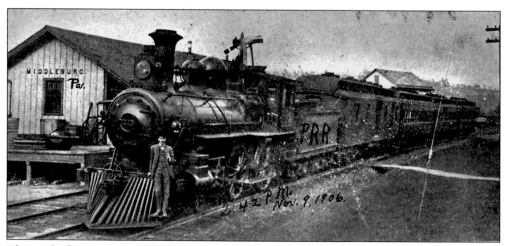

The goal of every railroad and the wish of every passenger was that the trains run on time. Not only is the date, November 9, 1906, noted on this card, but the time, 2:42 p.m., is also marked. The derby-wearing, cigar-wielding young man on the engine's cowcatcher is George Washington Wagenseller, publisher and editor of the Middleburg *Post*. The classic Pennsylvania Railroad 4-4-0 engine is vintage 1893.

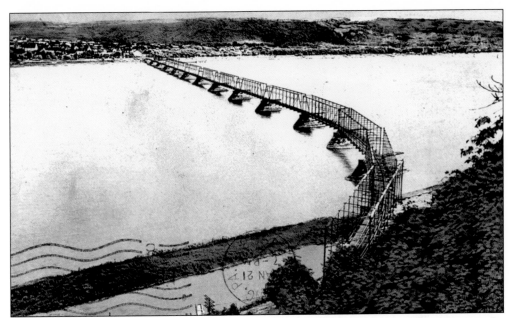

With many rivers to cross, including the Susquehanna, railroads needed bridges. This one, for the Reading Railroad, connects Sunbury with Snyder County at Shamokin Dam. The card is postmarked January 21, 1908. Note the canal in the foreground. This particular bridge was replaced by another before its piers were eventually removed in 1991 to make Lake Augusta even more conducive to recreational boating and other water sports.

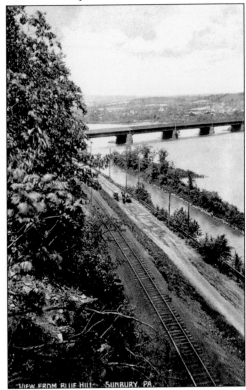

Printed in Germany and published by Conrad Ripple of Sunbury, this card offers an eagle's-eye view of the Reading Railroad as it runs along Blue Hill in northeastern Snyder County. Note the canal running along the unpaved Route 11 roadway. The fact that the covered bridge to Northumberland is still intact tells us that the photograph was taken before 1923; the wooden span burned on June 13 of that year.

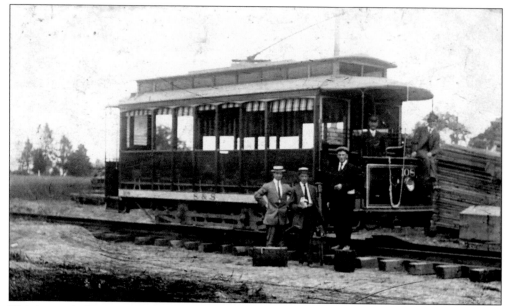

This is a real-photo postcard of car No. 108 of the Sunbury and Selinsgrove trolley line (note the S&S on the white side panel). The conductor and motorman are about to transport three young men, or "cake eaters," to use the term of the day. The card was sent from Selinsgrove on July 23, 1919, by Norman Luck to his nephew Harry Erb in Troxelville. The train car was purchased secondhand from Baltimore's United Railway and Electric Company.

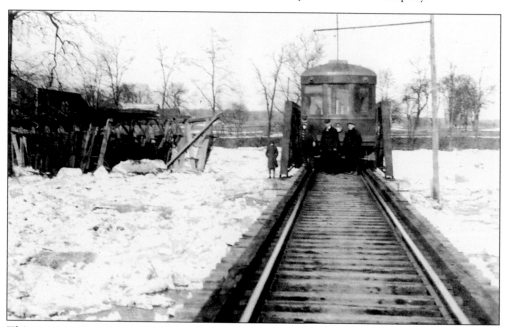

This car, No. 110 of the S&S line, was called *Black Mariah*. Car No. 110 and three others were purchased from the Cincinnati Car Company in 1916. *Black Mariah* is shown here coming from Monroe Township. The S& S ceased to exist at 12:01 a.m. on January 1, 1935, giving way to buses of the BKW Coach Line. Piers still exist in "the meadows" for a bridge that was washed away by the March 1936 flood.

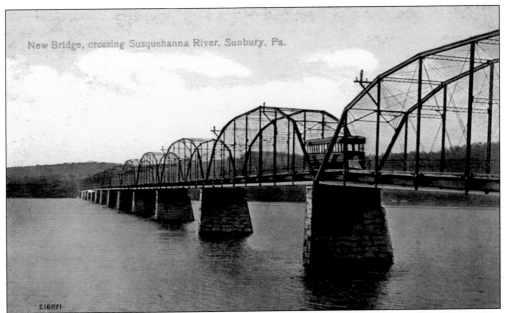

New Bridge, crossing Susquehanna River, Sunbury, Pa.

216871

Shown is a *c.* 1912 view of the Bainbridge Street Bridge, which connected Sunbury with Shamokin Dam. While an S&S trolley is visible, the span facilitated motor-vehicle and foot traffic as well. The bridge was replaced in 1928 by what was known for years as simply "the toll bridge." The current non-toll Veterans' Memorial Bridge was completed in 1986.

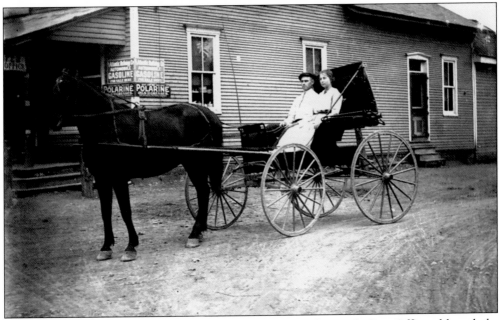

There is some question as to whether or not this building is the Benfer Post Office, although the sign at the upper left indicates that it is. The horse and buggy notwithstanding, the automotive age had dawned by the time this real-photo postcard was made in 1913. A sign advertises, "Atlantic Refining Co. Automobile Gasoline For Sale Here," and another touts, "Polarine Oils and Grease—Best for all Motors."

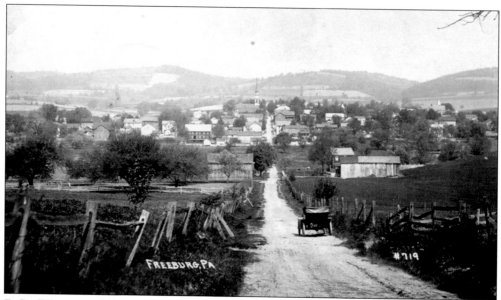

E. R. Wismer used this card to inform a Hatfield friend that he was "taking life easy here in Freeburg," something that was not hard to do in small, quaint Snyder County towns at the time. The card was mailed on August 10, 1923, but it was produced years earlier. It illustrates what motorists contended with before Gov. Gifford Pinchot's efforts to pave Pennsylvania roads. As is the case today, the steeple of St. Peter's Lutheran Church towers over all other Freeburg buildings.

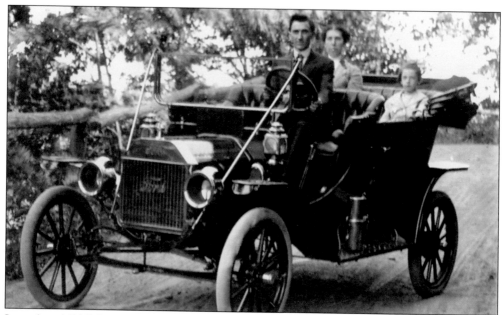

Longtime Middleburg jeweler Sam Hackenberg and his family proudly sit in their new 1910 Model T Ford. Sam must have been an adherent of legendary early auto racer Barney Oldfield; it was said that Sam "covered this distance [five miles] between Middleburg and Penns Creek in 19 minutes." While not a neck-snapping speed—a fraction better than 15 miles per hour—it obviously was noteworthy at the time.

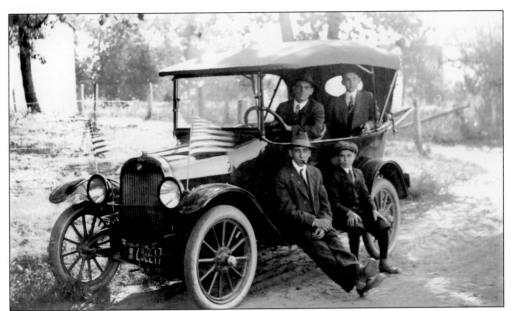

We know the year, 1917, from the license plate on this well-maintained 1914 Arrow automobile. The location is thought to be Kreamer. Listed on the back of the card are the names Arthur Hummel, Oscar Hummel, Henry Aurand, and Edward Aurand, but we do not know who is who. Apparently the group is made up of two fathers and their sons. The flags on this breezy summer day symbolize support of "Our Troops," in this case the World War I doughboys.

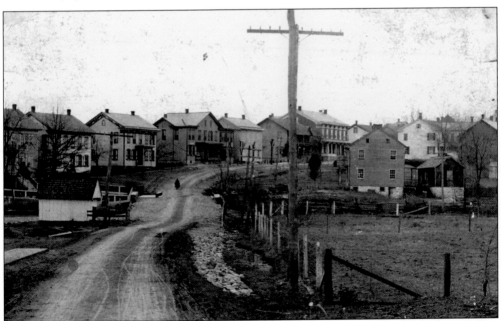

This view of Route 35 in the Mount Pleasant Mills–Fremont area, seen here in 1913, has changed little over the years. Most of these houses still stand. Heading east on the unpaved road is a lone motorcyclist. In 1903, the first application for state aid resulted in the first paved road in Pennsylvania, which ran from the middle of Shamokin Dam to the Bainbridge Street Bridge, a distance of about a quarter of a mile.

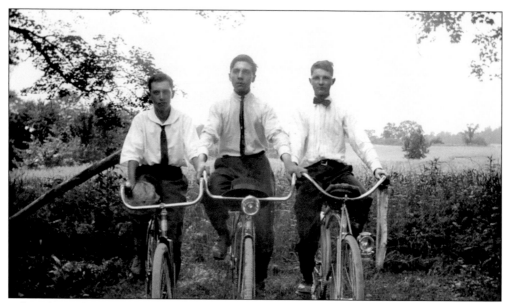

When the cycling craze hit the United States in the 1880s, bikes consisted of a gigantic front wheel and a much smaller rear wheel. By the mid-1890s, when bicycles had two similarly sized wheels, bike manufacturing had become a $60-million-a-year business. These three advocates of pedal power removed their hats and posed in 1921. They are identified as Kreamer youths Clyde Stettler, Lee Walter, and Raymond Mitchell. If Lee Walter is the middle man, he is especially proud of his Mercury bike.

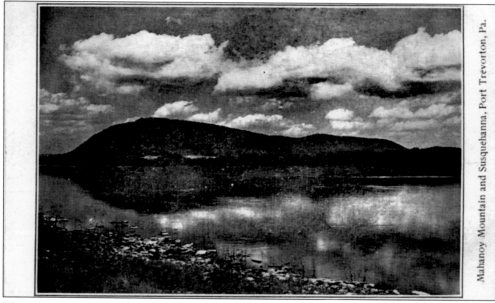

Mahanoy Mountain and Susquehanna, Port Trevorton, Pa.

This chapter opened with a view of the completion of the Susquehanna Trail, so it is appropriate that we close with a view of what one might see when traveling the five-lane thruway today. In the Port Trevorton area, one would see Mahanoy Mountain across the Susquehanna River. The scenic landmark, which is the tallest mountain in the area, stands some 1,400 feet above the road and riverbed. This view is from the 1930s.

Nine

CELEBRATE!

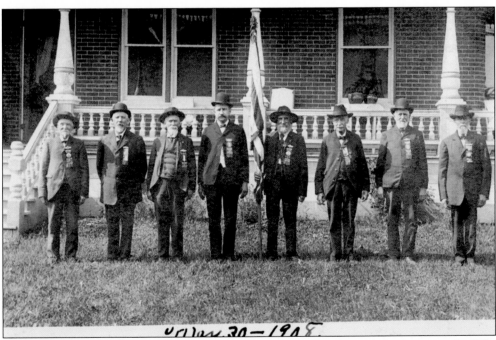

"Our boys," as licensed Gettysburg Battlefield guide Sue Boardman calls Company G of the 147th Pennsylvania Volunteers, were right in the thick of it at Gettysburg. Some of those soldiers, seen here observing Decoration Day in 1908, are pictured with a Grand Army of the Republic (GAR) group, which could also include Pennsylvania Volunteers from the 208th, 184th, 131st, and 35th. The Snyder County unit was one of a very few company units honored with a marker at the Gettysburg National Military Park.

SEPTEMBER 13, 1862.

We left our homes and entertered the Union Army and when the old Flag was Victorious, returned Home.

SEPTEMBER 13, 1904.

Forty-two years after that Date, we meet with our Children and Grand-children to celebrate the event.

YOURSELF AND FAMILY ARE CORDIALLY INVITED TO ATTEND

THE ANNUAL BEAN SOUP OF

OLD CO. "G," 147TH, PENN'A VOLUNTEERS,

IN COMRADE JERRY APP'S ORCHARD,

TUESDAY, SEPTEMBER 13, 1904.

WILL LEAVE CO. HEADQUARTERS UPON ARRIVAL OF 10:15 A. M. TRAIN.

This 1904 card announces that year's McClure Bean Soup event, held 42 years to the day after Company G left for the front. Listed on the back is the roster of Company G. While many men remained in the Snyder County area, others took a "land bounty" in lieu of a pension and relocated to the West. Their hometowns are listed as Lincoln, Nebraska; Akron, Ohio; Jewell, Kansas; Russell, Kansas; Van Lew, Ohio; and Corley, Iowa. GAR Post No. 355 initiated the Bean Soup celebration in 1891, and Sons of Veterans Post No. 65 took over in 1903.

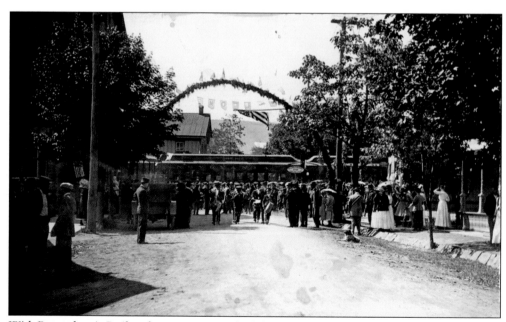

With Pennsylvania Railroad cars serving as a backdrop, a band, perhaps from Troxelville, marches through McClure. This is most likely part of the Bean Soup festivities *c.* 1910. If you hold the page up to a mirror, you may be able to make out the word "welcome" underneath the arch. Note the unconcerned dog in the right foreground.

While this may look like a nondescript pile of stones among a few spindly trees, Cold Spring Grove is where the McClure Bean Soup festivities were held for years. This view is from 1906. Each September 13, the anniversary of when Company G left for the front, Civil War veterans gathered to celebrate the accomplishments of Snyder County's GAR soldiers. Cpl. Dan Gross was the last surviving veteran. He passed away on July 14, 1930, at the age of 87, after being struck by an automobile.

In this 1910 image, a large, well-dressed group is enjoying the festivities of the annual McClure Bean Soup in "the grove." The Civil War veterans' reunion has been held annually since 1891. Into the 1960s, it was a traditional start of Republican political campaigns. Union Furniture Company lumber is seen in the foreground.

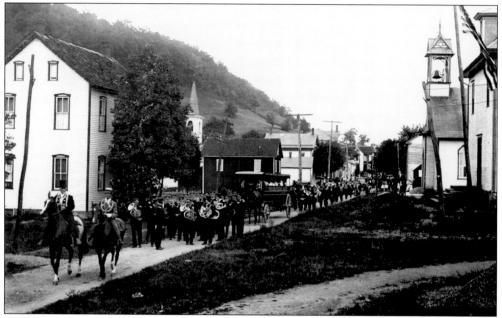

The Independent Order of Odd Fellows (IOOF) was a popular fraternal organization at the turn of the century. Here, looking east on Specht Street in McClure, we see the group's reunion parade, held on Friday, August 19, 1911. Behind the mounted parade marshals are the Troxelville Band and its wagon.

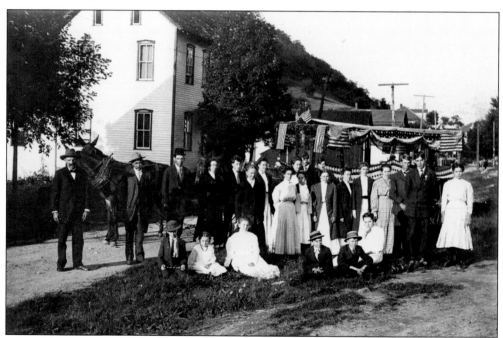

Odd Fellows reunions were not just about members parading; they were celebrations for the entire family, as evidenced by this group pictured in McClure in 1911. The horse-drawn, bunting-bedecked float provides a colorful and patriotic background for the several IOOF families shown here.

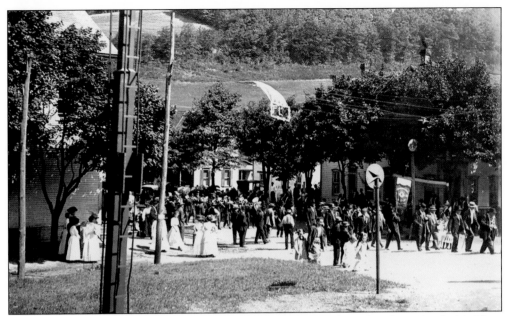

Bands and the line of march proceed along the parade route at the railroad crossing in McClure in this Odd Fellows reunion celebration in 1911. Just as they do today, parades drew sizeable and enthusiastic crowds. Note the group of ladies taking advantage of the shade trees at the left of this photograph.

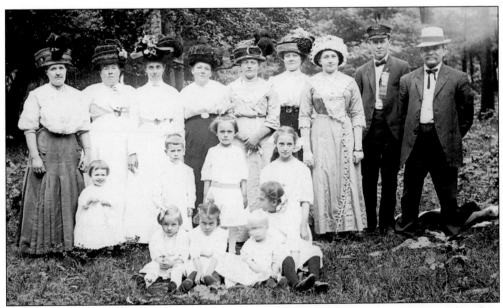

This real-photo card from Beaver Springs was posed for and produced somewhat earlier than the preceding cards. A note on the back mentions "the Fall IOOF picnic." The younger of the two men is wearing an Odd Fellows cap (its insignia is visible with a magnifying glass) and lapel ribbon.

The Reverend E. E. Gilbert served Lutheran churches in McClure and Mount Pleasant Mills in the early years of the 20th century. In a very neat script, he has written on the back of this card, "This is the class I confirmed at McClure in April, 1910." Note the apparent variance in ages of the confirmands.

While there is nothing definite to indicate that this Christmas greeting was conveyed by a church youth group, it is a pretty safe assumption to make. The card was postmarked in McClure on February 3, 1913. The drama was undoubtedly part of the 1912 Christmas holiday celebration.

We cannot be sure, but there is a good possibility that this group is composed of members of the popular Patriotic Order Sons of America. The portrait of George Washington is a clue to the group's affiliation. The beribboned men are likely attending a reunion in Kreamer *c.* 1909. Note another Washington picture affixed to the sturdy oak at the left.

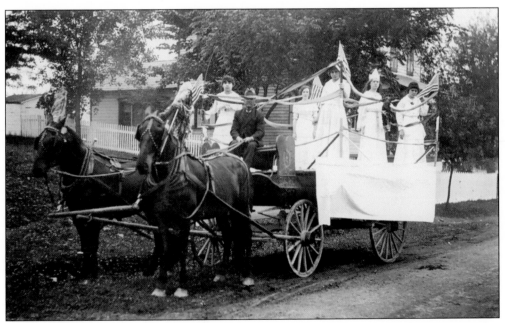

No one will likely confuse this for a Tournament of Roses Parade float, but the purpose, sincerity, and patriotic fervor of the young ladies makes it as attractive and appropriate as any more elaborate float. The group is part of a Patriotic Order Sons of America parade in Kreamer *c.* 1909.

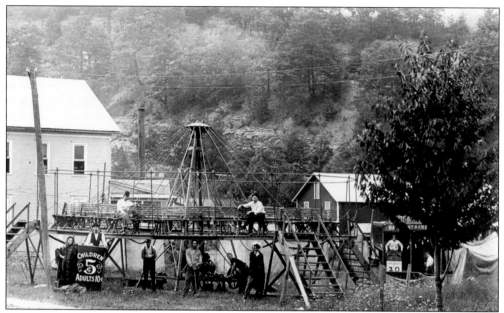

This photograph, also seen on the cover, depicts a McClure carnival merry-go-round, but no one has been able to pinpoint the exact locale. The ride, probably recently erected at the time the photograph was taken, is a bargain at 5¢ for children and 10¢ for adults. Another attraction at the right costs a dime for everyone. The card dates from the first decade of the 20th century.

At about the same time that the preceding photograph was made, a merry-go-round with horses showed up in Middleburg at Curt Graybill's field below the Hotel Middleburger. Jennie Erb, the little girl on the right, provided this information many years later. The other people pictured are not identified.

This carnival came to Selinsgrove *c.* 1921. The tents were pitched on one of the many fields and lots that dotted the borough at the time. A steam engine is seen at the center, but the big attraction was the "Overland Electric Theatre" at the right. Whatever is showing cost 10¢ to see.

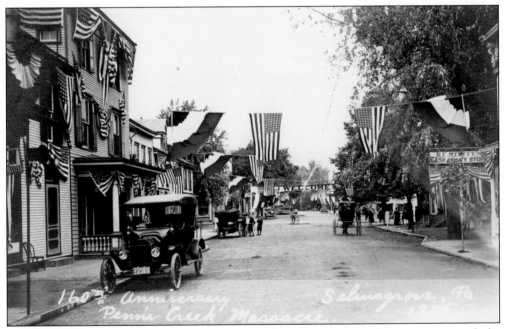

Exactly 100 years before Snyder County was formed, another history-making event occurred: the Penns Creek Massacre of October 16, 1755. Native Americans, emboldened by Braddock's defeat and urged on by the French, attacked unsuspecting settlers along the creek from New Berlin to Kratzerville. A dozen pioneers were killed, and women and children were carried off. William M. Schnure and others staged a commemoration 160 years later. This is South Market Street in Selinsgrove.

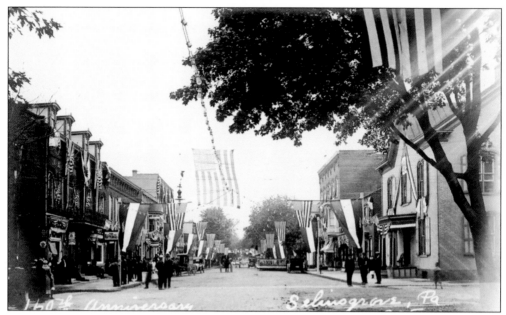

The first block of North Market Street in Selinsgrove is truly decked out for the 160th anniversary of the Penns Creek Massacre, October 14–16, 1915. The last day of the event coincides with the actual date that hostile Native Americans killed a dozen settlers along Penns Creek. At the left of the card is the National Hotel and restaurant. At the right is the building that is now J. Kleinbauer.

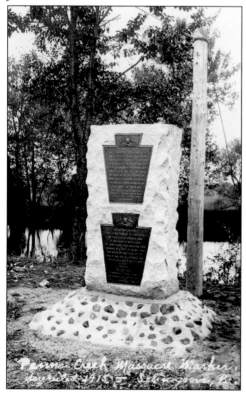

As part of the 160th anniversary of the Penns Creek Massacre in Selinsgrove, a group of participants walked from downtown to a spot near what is now Ulrich's Seafood Market, where a marker was unveiled that commemorated the attack of October 16, 1755. During the Great Depression, vandals made off with the metal plates, supposedly to sell them as scrap metal. For years, the plateless marker stood along the Old Trail; it is now gone.

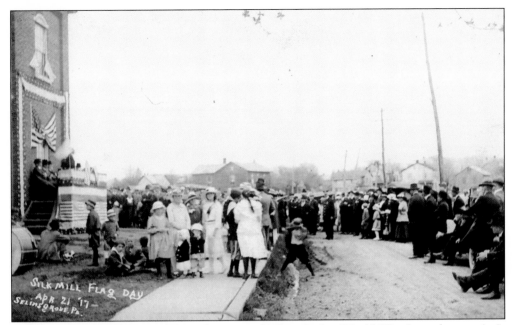

Traditionally, Flag Day is celebrated on June 14, but during World War I another patriotic "flag day" was observed on August 21, 1917. A sizeable crowd is assembled before what appears to be a speaker's platform in front of the William F. Groce Silk Mill on West Sassafras Street in Selinsgrove.

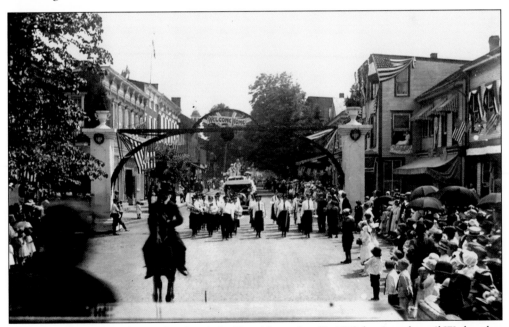

Johnny came marching home after Armistice Day, November 11, 1918, but it took until Wednesday, June 11, 1919, to officially welcome the soldiers home. The recently formed Beaver Springs Girls Band, shown here, was one of the parade's main attractions. The welcoming arch was moved from town to town for other celebrations. It can be seen in other postcards and photographs from that joyous summer.

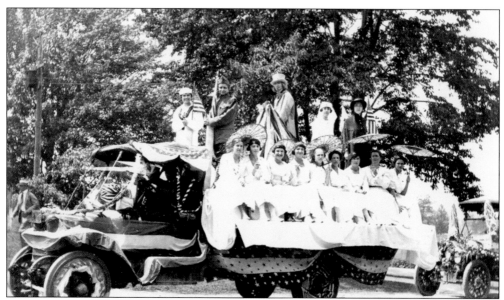

Another part of Selinsgrove's World War I welcome-home celebration were gaily decorated vehicles, some carrying a bevy of young ladies. Note those dressed as members of the military, Uncle Sam, and other patriotic characters. The celebration took place on Wednesday, June 11, 1919. Many Susquehanna University students served in the war; some were members of Unit No. 574, the Susquehanna Ambulance Corps, which won the French Croix de Guerre for gallantry.

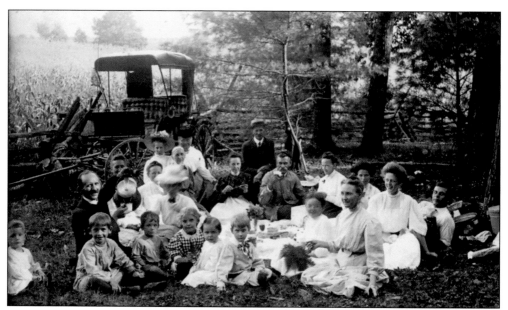

The Brungart family of Selinsgrove enjoys a picnic in midsummer 1908 (notice the height of the corn in the nearby field). Given the number of people pictured, this photograph most likely represents several branches of the Brungart family. Winifred W. Brungart mailed this card to a friend in Kansas City, Missouri. Eventually, the card found its way into the collection of Ron Nornhold of Troxelville.

Ten

POTPOURRI

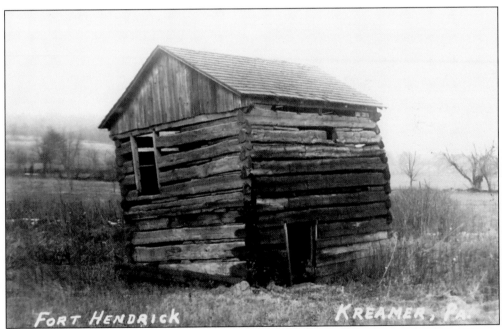

Probably very few people realize that there was once a military installation in Kreamer. Shown *c.* 1912 is Fort Hendrick, which was built in 1770. Better known as Schoch's Blockhouse, it was torn down *c.* 1917. A replica, clearly visible from Route 522, stands in its place today. Early Snyder County settlers constructed the facility near a spring on Mathias Schoch's land as protection from the Native Americans after the Penns Creek Massacre.

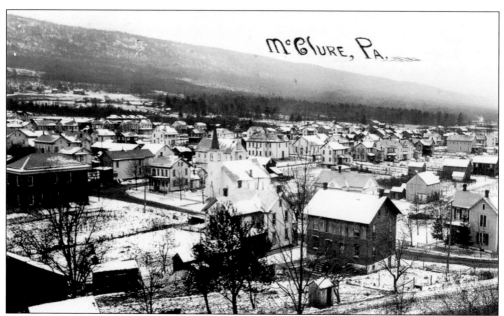

McClure is the westernmost community along Route 522 in Snyder County. With Shade Mountain as a backdrop, the town appears even more quaint with a covering of snow on the ground. The white Christ's Lutheran Church at the center is nearly camouflaged by the snow. Note the rather large stand of evergreens near the outskirts of town. This real-photo postcard is from 1899.

Richfield is one of Snyder County's most unusual communities because it is also in Juniata County. There is an interesting bit of folklore that theorizes how this came about. What is striking about this 1913 card is that the main focal points are two churches located opposite each other. The photograph was taken by a photographer named Morrow from Newport in Perry County.

Kratzerville is tucked away in the northeast corner of Snyder County. Its main street, Market Street, is shown here *c.* 1914. Note the fresh wagon tracks. Kratzerville lies about one mile south of Penns Creek—the body of water, that is, not the town of the same name. At first called Hesslers or Hesslerville, it became Kratzerville in 1847. The land upon which Kratzerville was established was owned by Daniel Kratzer.

A 1909 view of North Market Street in Selinsgrove shows the Keystone Hotel at the left. It was later known as the Sterner Hotel, and still later was called the Hotel Governor Snyder. More recently it was the Susquehanna Inn, and it now operates as BJ's Pub & BBQ Pit. The horse and buggy appears to still have been more popular than the automobile at this time.

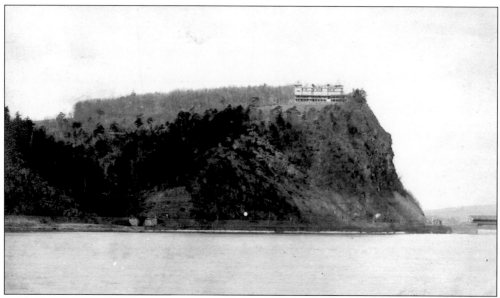

We know that this is a 19th-century photograph, because the magnificent Hotel Shikellamy, constructed in 1893, was destroyed by fire on May 4, 1898. The edifice was never rebuilt, but the land has been put to good use as Shikellamy Lookout State Park. The covered bridge at the right, leading from Snyder County to Northumberland, fell victim to fire on June 13, 1923.

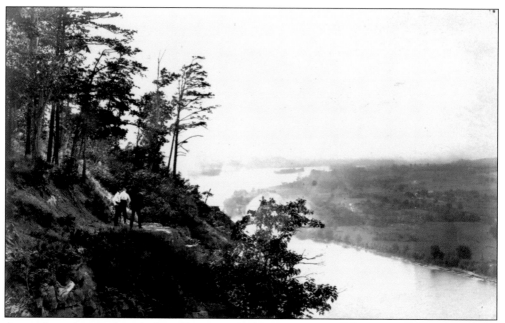

As scenic a view as there is for miles around, this scene can still be enjoyed today, although the land is somewhat more developed. The view, captured in 1897, looks north up the West Branch of the Susquehanna River toward Lewisburg. The three adventurers are standing on ground that is now part of Shikellamy Lookout State Park on Blue Hill in the northeast corner of Snyder County.

The author's Aunt Mame had hats similar to this; in 1910, they were the height of fashion. Sent to a Lewisburg patron, the card announces the "Fall and Winter Millinery Opening" of Mrs. J. E. Magee, Tuesday and Wednesday, October 11 and 12, 1910, in Kreamer.

YOU ARE INVITED TO OUR
FALL AND WINTER MILLINERY OPENING
OCTOBER 11TH AND 12TH 1910
MRS. J. E. MAGEE
KREAMER, PA.

Mrs. Rebecca (Forrer) Wagenseller
Selinsgrove, Pa.
Born November 20, 1840.
Mother will be 71 years of age Nov. 20th 1911. Will you kindly send her a Post Card?

This card represents a unique use of a postcard. It is a request for more cards, sometimes called a "card shower." The children of Mrs. Rebecca Wagenseller are asking that postcards be sent to her on her 71st birthday, November 20, 1911. The U.S. Post Office was processing nearly a billion cards a year at the time.

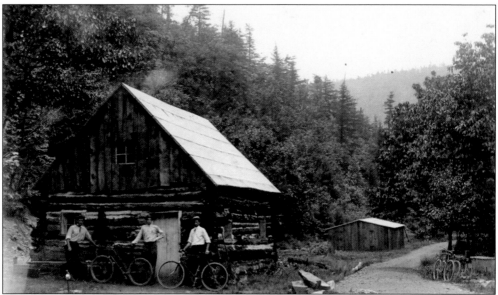

A man by the name of Pete (he signed no last name) sent this card to his friend, William G. Faulkner of Athol, Massachusetts, on June 24, 1911. He wrote, "This is a view of Bull Hollow Shanty in the mountains about five miles north of Beaver Springs." He mentions the road as a sample of what is being built "all over the mountains." The shack was used by road builders, shown here, who worked on what is now Route 235. Pete was likely one of the road builders.

This c. 1930 card was printed in Auburn, Indiana, and identifies Snyder-Middleswarth State Park as being located near Weikert. Snyder County residents and many others know that it is actually near Troxelville. While Tall Timbers, one of the few stands of virgin forest in the East, extends to cover both slopes of Jack's Mountain, an entrance to the park is on the Snyder County side.

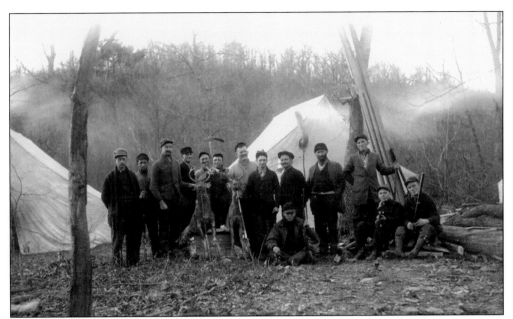

Considering that apparently only 2 of the 14 pictured nimrods "got his buck," there seems to be an overabundance of smiles. Perhaps the satisfaction really does lie in the hunt. Note that this Jack's Mountain camp features canvas tents rather than solidly constructed cabins. The card dates from *c.* 1921, and the hunters are from the Kreamer area.

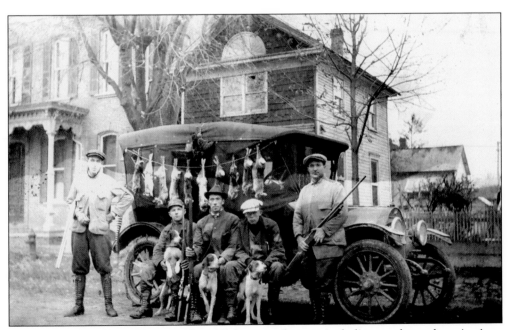

Home from the hunt is a group of Middleburg marksmen, including, perhaps, druggist Aura "Aurie" Snook. The number of rabbits and birds hung on the 1914 model automobile attests to the group's sharpshooting—or could it be the proficiency of their canine friends?

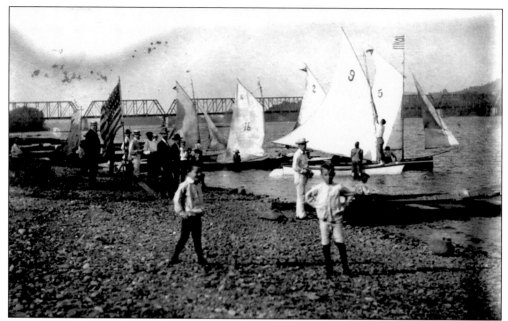

A section of the Susquehanna River, located south of the Sunbury-Lewistown Railroad bridge in Selinsgrove, was called the Inlet. This 1906 card shows activity leading up to the start of sailboat races. Racing was not for adults only. Other photographs show youngsters launching scaled-down sailboat models.

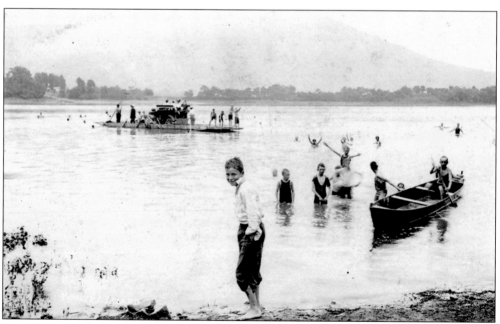

K + W = S. While not as scientific as $E=mc^2$, the equation is Kids + Water = Summer. With Hoover's Island located between Selinsgrove and Port Trevorton in the middle of the Susquehanna River, the area was an attraction to a sizeable group of summer fun seekers. Note the touring car being ferried over to the island, which is faintly seen in the background. The card is from 1912.

VETERANS—MEMORIAL—POOL MC CLURE, PA.

Community swimming pools are nothing new these days, but in 1950, when the Veteran's Memorial Pool was opened in McClure, it was cutting edge. Here, an appreciative group witnesses a well-executed swan dive by an unidentified aquanaut. The card was a communication between two young ladies who met at Brownie camp—Joy Knepp of McClure and Nancy Wagner of Selinsgrove. Knepp mailed the card on August 27, 1952.

ICE GORGE SELINSGROVE PA 2-20-17.

If you need proof of global warming or of old folks' tales that "winters were colder back in my day," this ice gorge in the Susquehanna at Selinsgrove should suffice. Taken on February 20, 1917, this photograph shows a group standing on a frozen-solid river with a wall of jammed ice behind them. Note the footprints leading out to the group. The ice wall looming in the background appears to be at least six feet high.

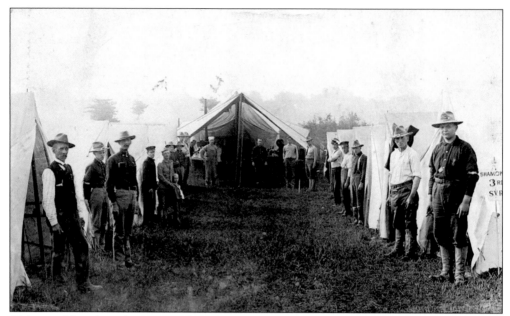

Citizen soldiers have been part of the fabric of the defense of America from Colonial times to the most recent conflicts. This pre–World War I group is spending its two-week summer encampment somewhere in Snyder County, perhaps at Rolling Green Park or Camp Ripple (which was north of Selinsgrove, where Lowe's is located today). Based on the tent markings, we know the soldiers are from Shamokin.

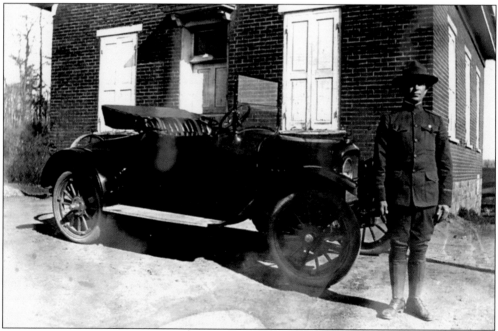

Willie Kratzer of Kratzerville has several reasons to celebrate. He survived the horrors of World War I trench warfare, and he has a late-model car. This real-photo postcard is from 1920. The photograph was taken at the one-room schoolhouse in Kratzerville, a building that still stands.

The Arlington Hotel was just one of several vying for the patronage of those living in Freeburg *c.* 1907. While some of those pictured are undoubtedly the hotel staff, others appear to be part of an organized group. The National beer sign above the door at the left is too shaded to determine its city of origin, but the Cold Spring beer, ale, and porter sign to the right advertises the brews of J. and A. Moeschlin of Sunbury.

In the early 1900s, before studio photography became commonplace, families and groups often posed for photographs for no other reason than that they could. Unlike many images from of this era, this one (*c.* 1906) lists the names of all six "West Enders" on the back. They are identified as Clair Knepp, Hurley Wray, Austin Snook, Loyd Yetter, Daniel Snook, and Ralph "Buzzy" Shawver, but no order is given. Right now would be a good time to get out those old family photographs and identify the people, places, and dates. Future generations will thank you.

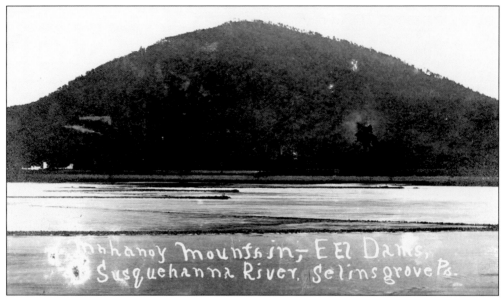

To the relief of many, eels are no longer considered a delicacy, at least in this country. But at one time, eels were highly prized as a gourmet dish. Both the Susquehanna River and Penns Creek had "eel walls" or dams, and many people fished for the long, thin aquatic animal. The dams appear on this 1908 card with Mahanoy Mountain in the background.

Penns Creek, known as Karoondinha in the days of first settlement, has been important in the development of Snyder County. In the late 1700s, the creek was used to transport grain to the mills of Selinsgrove in huge arks, which were bigger than rafts or canal boats. From there, the flour was taken down the Susquehanna to Baltimore. This bend in the creek is not far from where the Penns Creek Massacre monument was placed in 1915. The card is dated August 8, 1907.

In the message on this card, mailed from Beaver Springs on October 5, 1912, the sender mentions, "I have just had a drink out of this spring." People can still enjoy a cool, refreshing drink from the spring that gave Beaver Springs its name; it is located at the west end of town on property once owned by the Haines family. Beaver Springs was once known as Adamsburg, but another Adamsburg existed in Westmoreland County in the western part of the commonwealth.

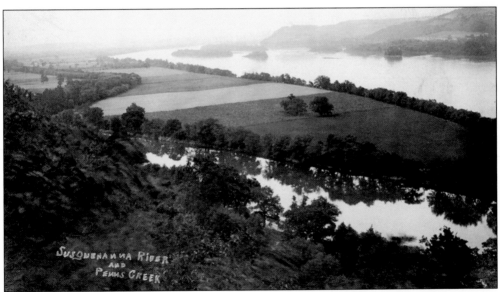

Some of the county's most fertile land is on the Isle of Que in Selinsgrove. In the 1950s, John W. Bittinger owned the large farm, which he had earlier managed for the Rockwell family. Bittinger was one of the county's leading citizens. He graduated from high school at age 15 and from college at age 19, and after a year of medical school he became a self-taught engineer, working on such diverse projects as the Bainbridge Street Bridge and the Sunbury Community Hospital. His farm provided tons of potatoes for Middleswarth's chips. The card dates from *c.* 1921.

The Kind We Raise in Kratzerville, Pa.

S.A. &A.P. 3030

Either railroad cars were smaller or melons were larger in 1911. Actually, this is one of those whimsical cards that have appeared as long as there have been postcards. The S.A. & A.P. 3030 markings on the heavily laden flatcar remain a mystery. The card was mailed from Kratzerville on June 19, 1911.

Sherman Strawser stands in the yard of the Snyder County Jail in Middleburg. The 29-year-old farmhand was found guilty of the murder of Kantz farmer Charles E. Gable. In confessing, Strawser said, "If I get the chair, I get the chair." Eventually, he got it. The murder was committed on Tuesday, February 12, 1935.

There is an undeniable charm in this real-photo postcard, but unfortunately we know little about the youngster shown. Noted on the back is "Carolyn, age 3, 1907." Carolyn and her new litter of puppies are typical of Snyder County kiddies of the era. Note the jerryrigged repair of the wheelbarrow's left handle.

Many U.S. presidents, from George Washington on, have been Masons, and the group is considered by many to be the nation's premier fraternal organization. The Selinsgrove lodge was constituted in 1824. The South Market Street Masonic Temple (Lafayette Lodge No. 194) was built in 1871 as an opera house. On the back is noted, "Meets Friday night on or before full moon." The local lodge took over the vacated Trinity Lutheran Church on October 27, 1984. A parking lot now occupies the site of the old lodge hall.

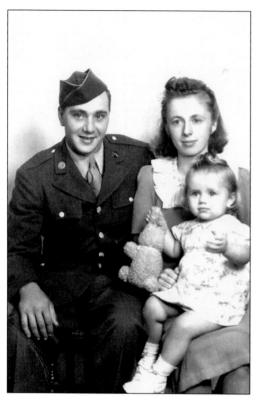

Even as late as the postwar 1940s, real-photo postcards were still being produced, despite the fact that the postcard industry had moved long before to "linens" and "chromes." Returning from World War II, veteran Charlie Polan is shown here in 1946 with his wife, Grace Seebold Polan, and the couple's daughter, 16-month-old Connie. The young family lived in Middleburg at the time.

Deltiologists, those who collect postcards as a hobby, will quickly recognize this as a "large letter" card. They were popular in the 1930s, 1940s, and 1950s. This Middleburg card could be adapted to represent any Pennsylvania town. It was mailed to a Middleburg "grandma," Mrs. Alvin Hassinger, on June 11, 1943, by her family, "Chas., Dot, and kiddies."